FANTASY UNDERGROUND

how to draw
fallen angels

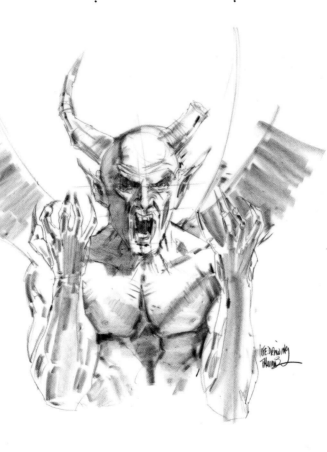

by Mike Butkus and Michelle Prather

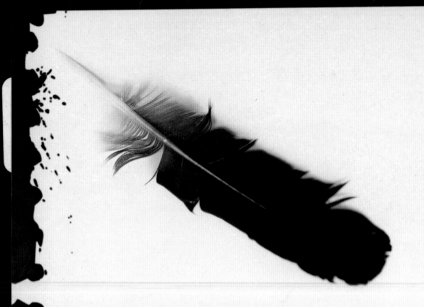

Project Manager: Michelle Prather
Designer: Shelly Baugh
Associate Publisher: Elizabeth Gilbert
Managing Editor: Rebecca J. Razo
Associate Editor: Emily Green
Production Design: Debbie Aiken and Rae Siebels
Production Management: Lawrence Marquez and Nicole Szawlowski

Printed in China.

3 5 7 9 10 8 6 4 2

2

FANTASY UNDERGROUND

how to draw
fallen angels

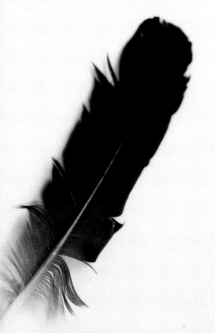

by Mike Butkus and Michelle Prather

www.walterfoster.com
Walter Foster Publishing, Inc.
3 Wrigley, Suite A
Irvine, CA 92618

Contents

introduction

Would you know an angel if you saw one? And would you know if its intentions were decent or diabolical?

The mystery and allure surrounding angels can be traced back to ancient times. No matter what the era, there is nothing more spellbinding to humankind than an immortal, manifest or imagined, that not only possesses intelligence exceeding that of humans but that has superhuman power and the ability to steer human will. Shapeshifting only fuels the fascination. An angel who visits earth to do good could be wingless and wearing an Armani suit, but wait . . . it could just as easily be a member of Satan's army sent from the underworld to tear your world apart.

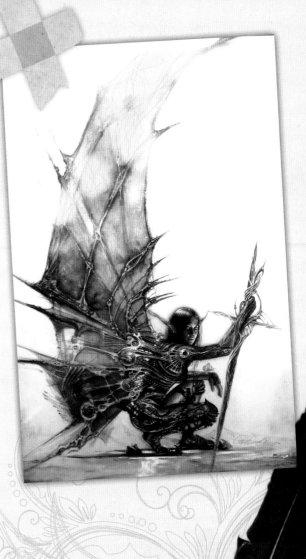

They're always among us, flitting to and fro through the ages in stories, religion, art, our imaginations, and sometimes our presence. The once-holy beings who fell from grace because their greed and ambition overtook them have devolved into demons of the darkness, eager to carry out Satan's ill will and ready to drive you down the path of depravity.

Welcome to the Fantasy Underground, where you'll learn about the dark side of angels so as not to be left unawares. Here, you can empower yourself by learning the history of angels and unearthing evidence of sightings and interactions with them. In addition to a glossary and much more, this book includes step-by-step instructions detailing how to capture these magnificent spirits on paper using drawing, painting, and computer techniques.

Don't be wary. Your will is your own, after all.

The question is: Is it strong enough?

6

Chapter 1: angel basics

a brief history of angels

Angels in Christianity

Angels' exalted role in modern-day Christians' spiritual universe owes debt to the Iranian prophet Zoroaster, who taught the tenets of good and evil around 1200 B.C. (or as late as 600 B.C., some scholars argue). As Zoroaster waded along the shore of the Daiti river, he had a vision in which one of seven angels presented itself to him before leading him to six other angels. Following this encounter, what Sumerians considered "winged humans" around 3000 B.C. and ancient Babylonian and Assyrian cultures later called "winged messengers" became known as archangels that symbolized the seven laws of morality. These seven archangels, claimed the prophet, guided him throughout the duration of his life.

Darius the Great of Persia (550 B.C. to 486 B.C.), declared Zoroaster's monotheistic faith the foundation for his realm's religion. In spite of his decree, he was known for his tolerance of coexisting faiths, as long as their followers were law-abiding and peaceful. When the Jews, who were aided by the ruler in the restoration of their temple, were exiled from Babylon, they took Darius's interpretation of Zoroastrianism with them, integrating the idea of archangels into early Judaism. Later, adherents of Judaism who converted to Christianity infused their new faith with angel lore taken from the Judiac teachings in the books of Daniel, Enoch, and Tobit.

Early Christianity dictated that angels were governed by God to serve humankind. As intermediaries between man and God, angels kept watch over life on earth; relayed prayers from earth to heaven; oversaw baptism and penitence; and exemplified true devotion to God and Christ. Although angels' place in Christianity was fiercely debated throughout early Christendom, St. Thomas Aquinas, the most revered theologian of the Middle Ages solidified their importance in his *Summa Theologiae* and in lectures that examined angels, demons, and the hereafter. He supported the belief that every Christian was watched by a guardian angel, and that angels were the highest order of creation. It was Aquinas's exploration into the realm of angels that shaped Christian beliefs about the divine beings for the following eight centuries.

Today's Christians accept that angels aren't idols worthy of worship, but rather messengers of God who help maintain peace on earth. Although a multitude of angels have been named throughout time, the

8

Catholic Church acknowledges only four: Michael and Gabriel, who appear in the Bible; Raphael, named in the Book of Tobit; and Uriel, who appears in the second book of Esdras.

Angels in Judaism

Just as Judaism predates Christianity and Islam, angelology appears in Judaism before it does in the other religions. According to the Jewish Encyclopedia (1901-1906), the influence of Babylonian and Persian systems of belief during and after the exile drastically altered the angelic lore of the Jews. As monotheism took hold, and JHWH become accepted as a supreme being, the need to form his royal court arose. It was during this time that an intricate system of angels evolved alongside a system of spirits closely resembling that of Zoroastrianism. The seven archangels were assigned names in Enoch, and guardian angels were defined as souls of the dead, spirits who walk among the living, and other protective spirits.

As in Christianity, an angel is a heavenly intermediary force who is a subject of God in Judaism. Members of his court include the malach ("messenger"), irinim ("watchers"), cherubim ("mighty ones"), sarim ("princes"), seraphim ("fiery ones"), chayyot ("holy creatures"), and ofanim ("wheels"). Their tasks are many. They could be charged with delivering important messages to humans or with thwarting Israel's enemies.

Fallen angels appear frequently in post-biblical literature, in both the Book of Enoch and the Book of Jubilees. In the latter, fallen angels are said to have visited earth to teach mankind about the benefits of societal order, but once they got there, they were seduced by the daughters of men before they could complete their intended mission.

Angels in Islam

Founded by the Prophet Muhammad in the year A.D. 622, Islam spread throughout the surrounding areas and into North Africa and southern Spain following Muhammad's passing in 632. Sura 2, verse 177 of the Koran refers to the belief not only in Allah and the Last Day, but in "the angels and the Book and the messengers." Angels in Islam are devoted to serving and obeying Allah, and one of their most important roles is to carry messages between humans and their master.

The Koran depicts these dutiful beings as a combination of light and fire—entities that will never disobey and succumb to temptation. On earth, they assume the shape of humans, and can address other humans vocally, depending upon their objective.

As in Judaism and Christianity, Gabriel and Michael (Jibrail and Mikail) are regularly mentioned in the Koran as two of Islam's chief archangels. Jibrail was the archangel who dictated the holy words of the Koran to the Prophet Muhammad and accompanied him to heaven. He serves as the messenger, and is considered by many Muslims to be the Holy Spirit. Mikail is often depicted as the archangel of mercy, and is tasked with rewarding people who are good in this life. Israfil (or Raphael), the third archangel, will blow a horn to signal Judgment Day. His first blow, according to the Koran, will decimate all existence, but his second blow will give life back to all humans. Izra'il (Azrael), the fourth archangel, is the angel of death who separates the souls of mortals from their bodies. The care taken to remove the soul depends upon its quality. If the person was an unsavory character in life, the removal won't be pretty; but if the person stood on firm moral ground, he won't feel a thing.

Satan and Devil are both established names in the Koran. As in Christianity, Satan began as a good angel, but in the Koran, it's his refusal to the share the worship of Adam that gets him cast out of paradise.

fallen angels

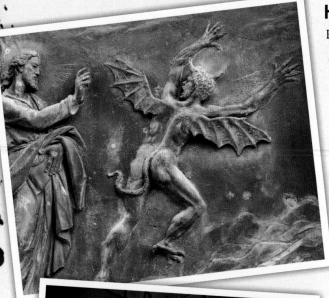

He Who Wanted More

Early Christians and coexisting Jews believed that angels fell from grace as a result of their lust for human women. But the most widely accepted version of the angels' fall begins when Lucifer ("Bright Son of the Morning" in Hebrew) was created above the seraphim, outranking the other angels guarding God's throne. His twelve wings further exemplified his magnificence in comparison with the hosts of angels that surrounded him. But Lucifer's beauty and grandeur got the best of him. Instead of remaining humble in the face of God, Lucifer became prideful about his closeness to Him. Confident in his supernatural powers, he grew ambitious, and dared to challenge his Master's rule by seeking to control his own destiny. To forward this epic uprising, Lucifer erected an army of rebel angels who shared his frustration over being subject to divine rule, and led them into battle.

Lucifer's army of angels, fueled by arrogance and envy, were no match for God's holy infantry and the archangel Michael who commandeered it, however. In Revelation 12:9, we learn the outcome: "And the great dragon was cast out, that old serpent, called the Devil, and Satan, which deceiveth the whole world: he was cast out of the earth and his angels were cast out with him."

For his gross misjudgment, Lucifer, along with one-third of the heavenly host who shared his rebellious nature, were banished to the depths of hell. From that point forward, Lucifer was known as Satan; and he and his angels-turned-demons were condemned to eternal suffering. Of course, if you're demonic in nature, your idea of fun is spreading a bit of anguish around the world, which is exactly what these evil beings set out to do. There were simply too many mere mortals, weak in moral fortitude and naive enough to take the bait, to resist.

Demons' Dirty Work

Judaic demonologies separated demons into classes that varied throughout the ages. The teachings of the Kabbalah asserted that the source of evil was the left pillar of the Tree of Life. By the thirteenth century the notion that 10 evil *sephiroth* were in constant opposition to 10 holy *sephiroth* had developed. Other beliefs regarding demons proclaimed them the product of night terrors, dark beings who ruled the nighttime alongside angels, or diseases incarnate.

As Christianity gained momentum, so did tales of demons, which now borrowed from ancient Jewish and Middle Eastern lore. In the Middle Ages, demons were thought to work in tandem with witches. As part of their mission to exploit the weakness of humans, both male and female demons (incubi and succubi, respectively) were said to creep into the beds of unsuspecting mortals and copulate with them. Incubi were especially fond of virtuous females, be they nuns, virgins, or widows vowed to celibacy. Because tales of intimate encounters with demons

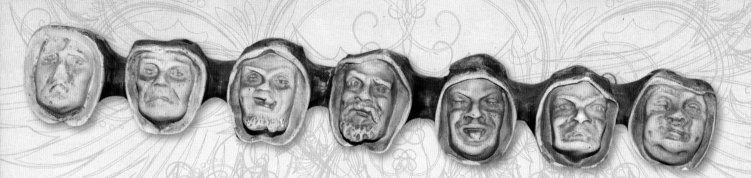

became so prevalent by the fourteenth century, the unfortunates plagued by these devilish creatures were urged to take many faith-based emergency measures, including confession, reciting the Lord's Prayer, or in extreme cases, exorcism.

In modern Christian theology demon angels remain subject to God's final judgement, after which they'll be relegated to an eternal hell. Until then, Satan is free to order demons to tempt and deceive mortals, as well as take captive the souls of the weak. If a person is of little faith, for instance, he or she is vulnerable to demonic possession that would likely result in evil acts.

The Seven Deadly Sins

All too aware of the fact that demons are dead set on steering mortals toward a sinful existence, conscientious Christians make it a point to avoid committing any one of the Seven Deadly Sins (or Cardinal Sins), a classification of awful vices drawn up in early Christendom to educate souls plagued by original sin. Of course, how bad can a sin really be unless it's ruled by a depraved demon? In an attempt to further categorize demons, theologists and clerics paired the most powerful of the fallen angels with its respective sin. Leviathan, the serpent demon who ruled the seas, was identified with envy, while Beelzebub, Satan's second-in-command was associated with gluttony. Mammon, the demon of riches was appropriately paired with greed; Asmodeus, who loved to instigate marital strife, with lust; and Lucifer, our star angel who risked it all to rebel against God, with pride. Belphegor took pleasure in seducing men with wealth, so he became the demon of sloth. And, of course, there was no better match for wrath than Satan, the ruler of hell and its inhabitants.

Tales of the Underworld

The idea that hell is the vast holding tank for Satan, his demon legion, and the souls of transgressors is said to predate written history, with the earliest accounts of a "Land of the Dead" etched onto clay tablets found in a location that is now modern-day Iraq. Many of the hallmarks we associate with hell today—boats and boatmen, a river, and bridges, for instance—were believed by the people of the area, including Sumerians and Babylonians, to be characteristics of the underworld. It's hard to deny that Zoroaster's belief in good and evil likely greatly influenced the Judeo-Christian understanding of hell. His teachings that Ahura Mazda, the upholder of truth, dwelled on high with seven angels, while the Angra Mainyu ("evil spirit") remained concealed below the earth, free to command the devils subservient to him to impose his wrath upon the human world, closely parallel the Christian concept of heaven and hell. Zoroaster even spoke of a great battle between good and evil that would negate hell, end evil forever, and allow good to prevail forevermore.

Dante Alighieri's *Inferno*, which details his allegorical travels through hell in the *Divine Comedy*, offers one of the most exhaustive depictions of the underworld that exists. In it, a vision of the poet Virgil materializes to tell Dante that the only way out of the dark wood in which he finds himself is to journey through the underworld. As Virgil leads him through the nine levels of hell, it becomes clear that each wrongdoing is appropriately punished, as in the case of the fortune-tellers who were cursed to walk backward because they could no longer see ahead. *Paradise Lost*, the epic work of English poet John Milton was published more than three centuries later, in 1667, and not only made hell more realistic, but Satan more intriguing with his charisma and knack for persuasion.

In spite of all the tales of fire and brimstone, a "house woe with pain," as Milton wrote, there are many who believe that hell is actually mankind's sinful, sometimes stormy existence on earth. The problems that we created for ourselves, whether environmental or societal, are our punishment for wanting beyond what we ever needed, not unlike the retribution the fortune-teller received in Dante's allegory. Regardless, there's always the possibility that good or demonic angels are roaming the streets in the guise of humans. That's why you should know what to look out for.

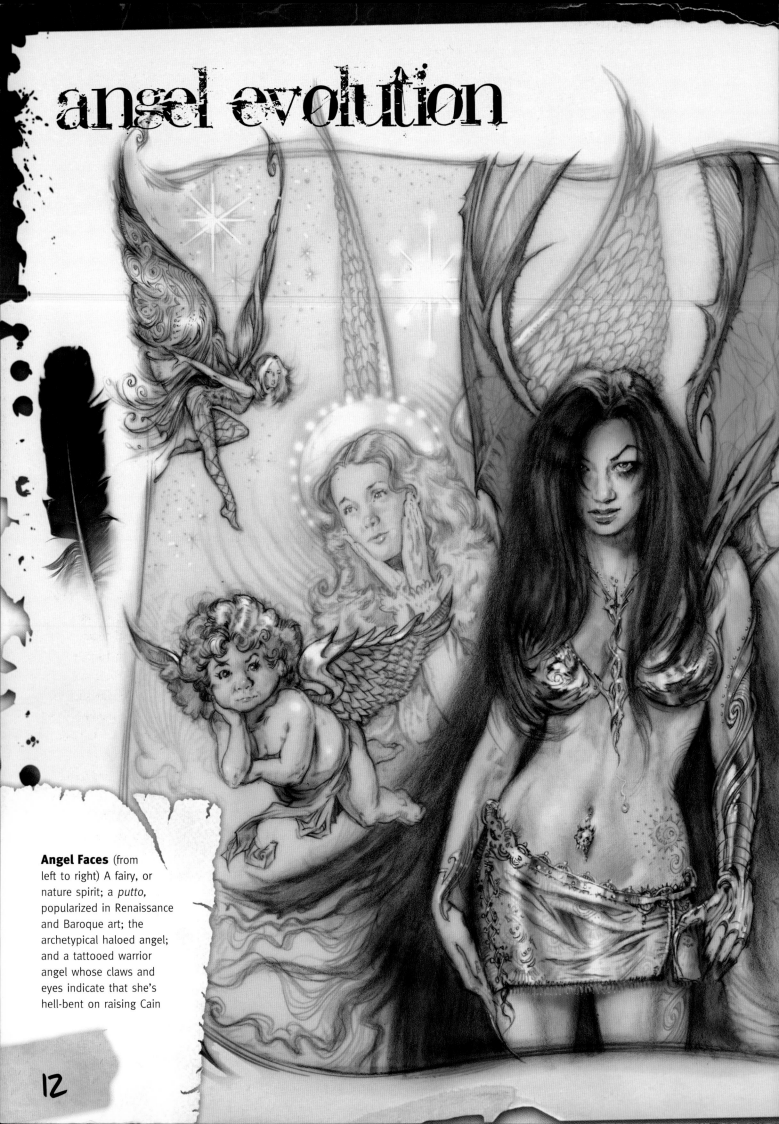

angel evolution

Angel Faces (from left to right) A fairy, or nature spirit; a *putto*, popularized in Renaissance and Baroque art; the archetypical haloed angel; and a tattooed warrior angel whose claws and eyes indicate that she's hell-bent on raising Cain

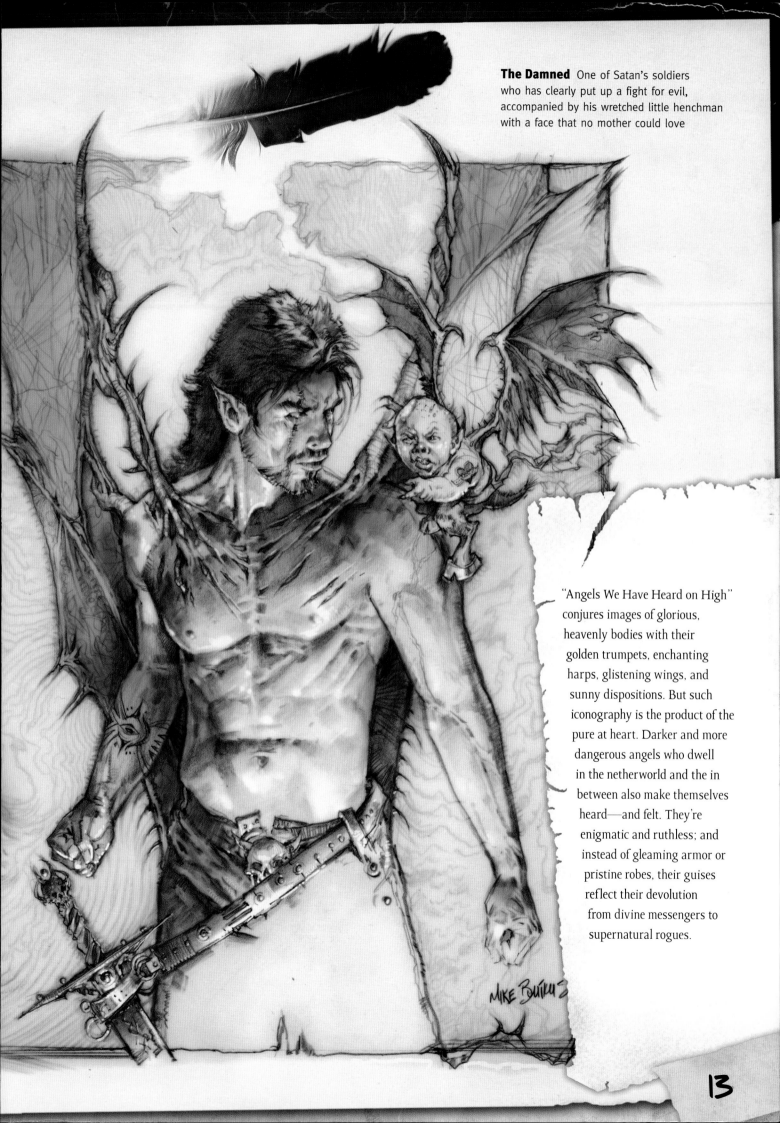

The Damned One of Satan's soldiers who has clearly put up a fight for evil, accompanied by his wretched little henchman with a face that no mother could love

"Angels We Have Heard on High" conjures images of glorious, heavenly bodies with their golden trumpets, enchanting harps, glistening wings, and sunny dispositions. But such iconography is the product of the pure at heart. Darker and more dangerous angels who dwell in the netherworld and the in between also make themselves heard—and felt. They're enigmatic and ruthless; and instead of gleaming armor or pristine robes, their guises reflect their devolution from divine messengers to supernatural rogues.

MIKE BUIKU

13

angel wings

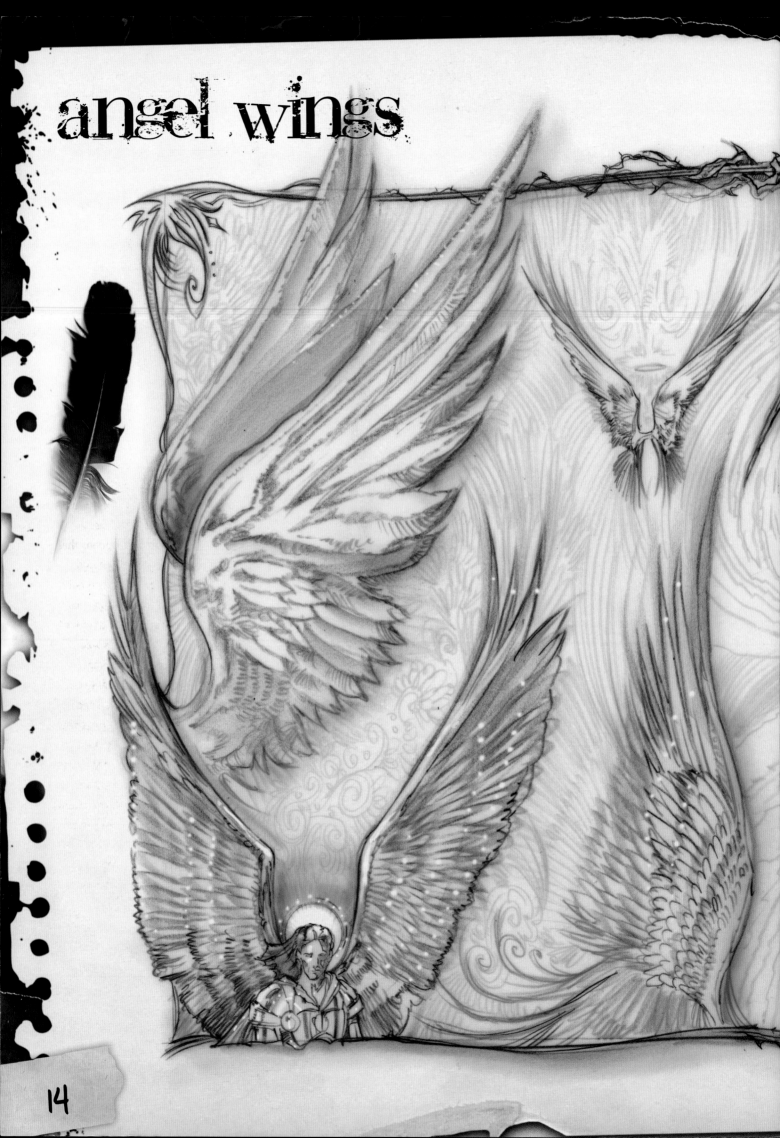

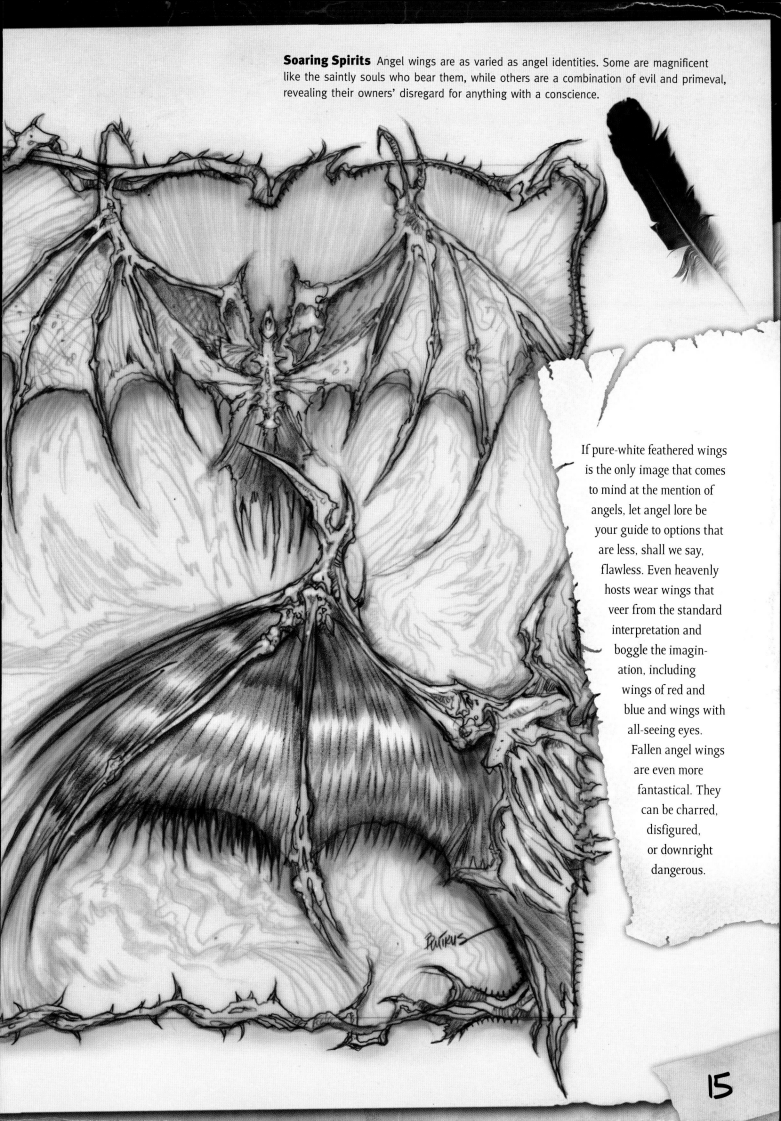

Soaring Spirits Angel wings are as varied as angel identities. Some are magnificent like the saintly souls who bear them, while others are a combination of evil and primeval, revealing their owners' disregard for anything with a conscience.

If pure-white feathered wings is the only image that comes to mind at the mention of angels, let angel lore be your guide to options that are less, shall we say, flawless. Even heavenly hosts wear wings that veer from the standard interpretation and boggle the imagination, including wings of red and blue and wings with all-seeing eyes. Fallen angel wings are even more fantastical. They can be charred, disfigured, or downright dangerous.

angel accessories

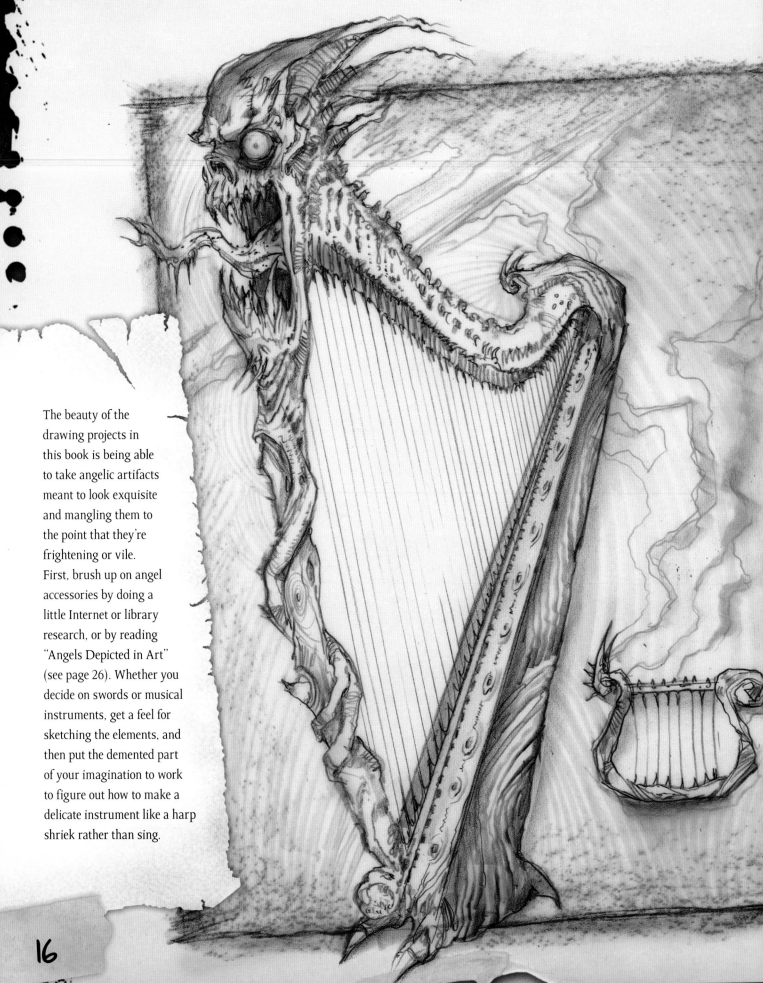

The beauty of the drawing projects in this book is being able to take angelic artifacts meant to look exquisite and mangling them to the point that they're frightening or vile. First, brush up on angel accessories by doing a little Internet or library research, or by reading "Angels Depicted in Art" (see page 26). Whether you decide on swords or musical instruments, get a feel for sketching the elements, and then put the demented part of your imagination to work to figure out how to make a delicate instrument like a harp shriek rather than sing.

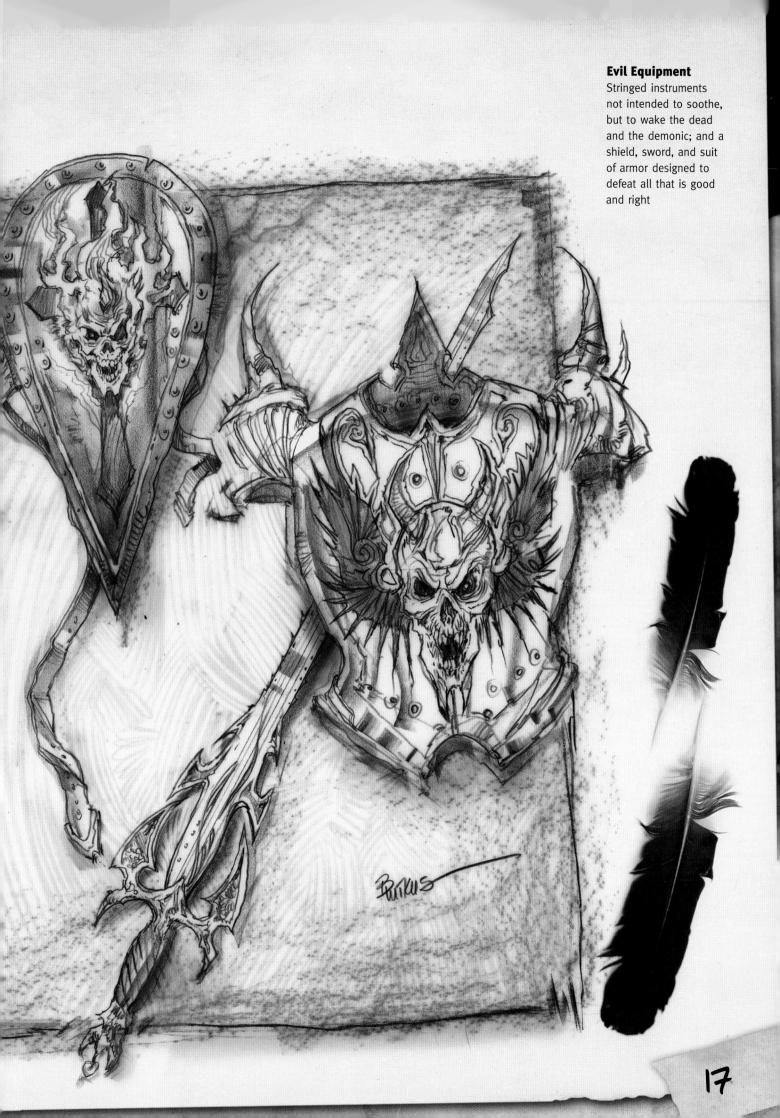

Evil Equipment
Stringed instruments not intended to soothe, but to wake the dead and the demonic; and a shield, sword, and suit of armor designed to defeat all that is good and right

Chapter 2: drawing

drawing materials

Drawing angels is a bit simpler than painting or rendering them on the computer, so let's start here. Basically, drawing consists of indicating shapes and defining *values* (the lightness or darkness of a color or of black). Because one relies so heavily on value to represent the subject, it's important to include a range of values for variety and contrast. Keep this in mind throughout your drawing process—from the beginning stages to the final details.

Colored Pencils

Materials Checklist
To complete all the drawing projects in this book, you'll need to purchase the materials below. Note that the exact materials needed for each project are listed at the start of each project:

- Multimedia vellum paper
- Colored pencils:
 black
 30% cool gray
 50% warm gray
 50% cool gray
 Tuscan red
- Black charcoal pencil
- Eraser
- Tracing paper
- Pad of rough or smooth newsprint
- Pencil sharpener
- 600-grit sandpaper (optional)
- Photoshop® (optional; see page 103)
- White gouache (optional)
- Small paintbrush (optional)

Charcoal Pencil

Eraser

Sharpener

White Gouache

Light Table

The projects in this book will be easiest if you have access to a light table, such as the one shown on the right. This illuminated surface makes it possible to create a clean outline from a sketch, simply by placing a sheet of paper over your sketch and tracing. If you don't have a light table, you'll want to keep your initial sketch lines very light so they can be erased at a later stage.

Pencils

Graphite drawing pencils are generally graphite "leads" encased in wood. The lead comes in grades and is usually accompanied by a letter ("H" for "hard," or "B" for "soft") and a number (ranging from 2 to 9). The higher the number accompanying the letter, the harder or softer the graphite. (For example, a 9B pencil is extremely soft.) Hard pencils produce a light value and can score the surface of the paper, whereas softer pencils produce darker values and smudge easily. For this reason, stick to an HB (aka #2) pencil, which is right in between hard and soft pencils.

In addition to graphite pencils, you will also use a charcoal and a few colored pencils. Charcoal, (made up of burnt wood), is a dark, rich medium that can give a drawing dramatic contrast. Be careful—it smears easily! Colored pencils are less likely to smear and come in a wide range of colors. (See also "Colored Pencils" on page 69.)

Kneaded Eraser

A kneaded eraser is a helpful tool that can serve as both an eraser and a drawing tool. It can be molded into any shape, making it easy to remove graphite from your drawing surface. To erase, simply press the kneaded eraser onto your paper and lift. Unlike kneaded erasers, rubber or vinyl erasers can damage delicate drawing surfaces, and it's not as easy to be precise.

Paints

The project in this chapter involve mostly drawing, but they do suggest paint to accent areas here and there. The gouache (an opaque type of watercolor) is water-soluble, so you'll need a jar of water and some paper towels when using it. You can use either natural or synthetic hair bristles with gouache paint.

Workable Spray Fixative

Coating your drawings with a layer of spray fixative can help prevent smudging as you develop your drawings. It's easy—especially while using charcoal—to accidentally smear your strokes. Workable spray fixative allows you to spray occasionally throughout your drawing process, so you can prevent accidents along the way.

Drawing Surfaces

Traditional drawing paper comes in three types: hot-press (smooth), cold-press (textured), and rough. Choose your texture according to your desired look. In general, rough paper produces broken strokes; it's not conducive to creating detail, but it's ideal for a sketchy style. Smooth paper allows for smooth, controlled strokes. In this chapter, the projects call for vellum paper and rough or smooth newsprint, which offer suitable surfaces for a multimedia drawing approach.

angel of death

This demented angel clearly fell hard when he fell from grace. With ragged horns, pointy bat ears, and claw-like hands that could terminate the life of an evildoer with one clench, our angel is a modern-day interpretation of classical depictions of the demonic underworld. Beware: With the right shading and detail, you could breathe more life into this dark character than is advisable.

Materials
- Pad of rough or smooth newsprint
- Black charcoal pencil
- Black colored pencil
- Tracing paper

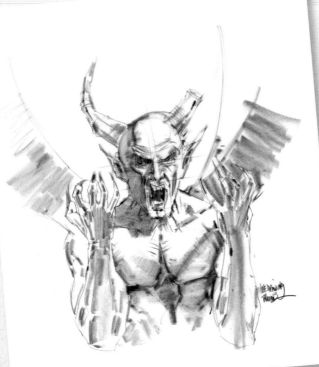

◄ **Step One** We begin this illustration of a psychotic angel of death, fraught with rage, with a thumbnail sketch using a black colored pencil over tracing paper. First, do a linear quick sketch drawing, and then use the side of the pencil for shading. Remember to keep the strokes short and chiseled. (You can transfer this sketch; see "Transferring a Drawing" on page 23.)

► **Step Two** Mastering the art of figure drawing is the foundation of most great draftsmen. In the absence of a screaming model with horns, I referenced images from the photo shoot for the cover art of this book. Using a black charcoal pencil, start the finished drawing on a pad of newsprint. Begin with a linear drawing, and, next, map out the shadow patterns.

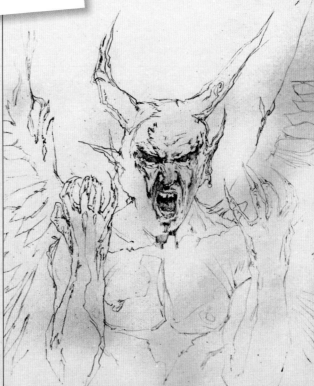

Transferring a Drawing

To begin the projects in this book, you might find it helpful to trace a basic outline of the final piece of art (or one of the early steps). Transferring the outlines of an image to your drawing or painting surface is easier than you may think. The easiest method for this involves transfer paper, which you can buy at your local arts and crafts store. Transfer paper is a thin sheet of paper that is coated on one side with graphite. (You can also create your own version of transfer paper by covering one side of a piece of paper with graphite from a pencil.) Simply follow the steps below.

Step 1 Make a photocopy of the image you would like to transfer and enlarge it to the size of your drawing paper or canvas. Place the transfer paper graphite-side-down over your paper or canvas. Then place your photocopy over the transfer paper and secure them in place with tape.

Step 2 Lightly trace the lines that you would like to transfer onto your drawing or painting surface. When transferring a guide for a drawing project, keep the lines minimal and just indicate the position of each element; you don't want to have to erase too much once you remove the transfer paper.

Step 3 While tracing, occasionally lift the corner of the photocopy to make sure the lines are transferring properly. Continue tracing over the photocopy until all of your lines have been transferred.

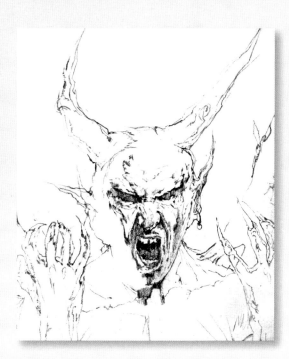

◀ Step Three In defense of the model who posed for the cover art, I did drastically distort and exaggerate the facial features to get the desired look. I brought down his jaw even further, lengthened the eye sockets, and inserted a gap between his front teeth for good measure. When the linear drawing is to your liking, use the side of the pencil again to begin shading in the shadow patterns. Adding more detail within these shapes isn't necessary, especially if the light and shadow patterns are well designed and accurately placed.

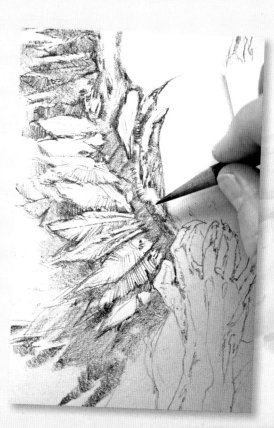

▶ Step Four Next, start on the wings. Try to keep the edges soft and the majority of the wing in shadow. Notice that there are hints of bird-like features, and that the shapes are chiseled and graphic. Even without a photo reference, try not to leave the shapes too ambiguous. Be confident about what you make up, or the viewer won't believe in it. Now, add a strong core shadow and a highlight down the middle to make the wings appear structurally sound.

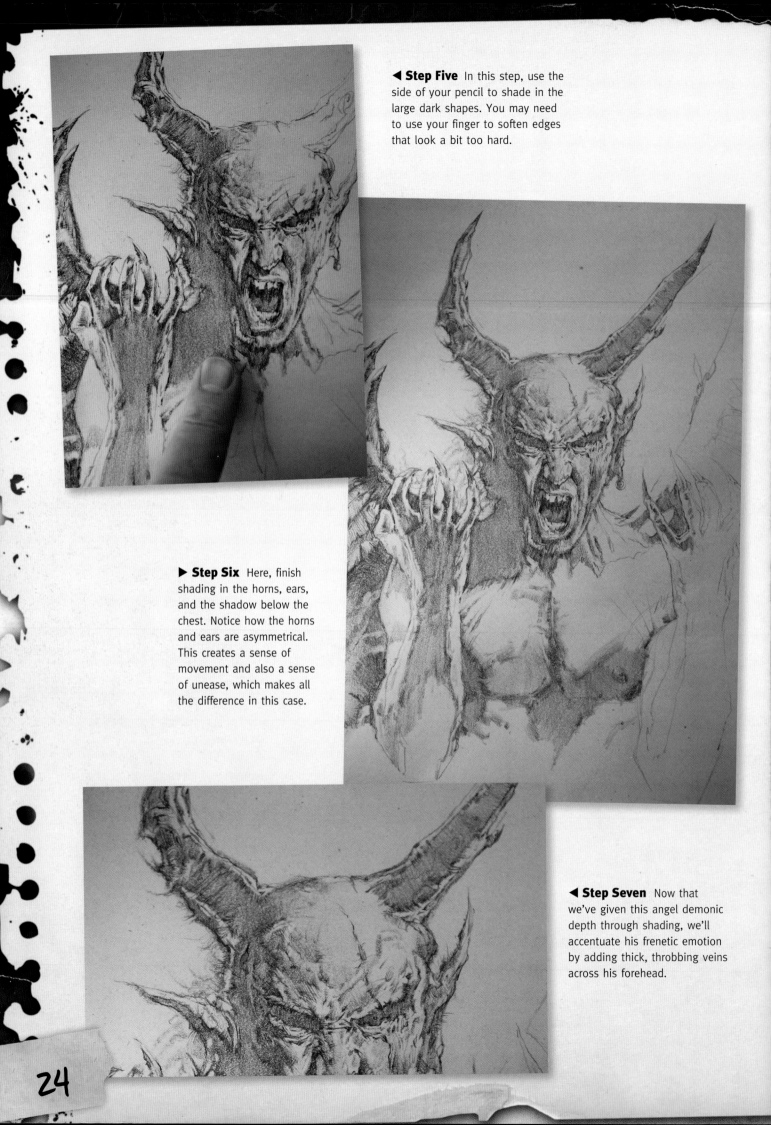

◄ Step Five In this step, use the side of your pencil to shade in the large dark shapes. You may need to use your finger to soften edges that look a bit too hard.

► Step Six Here, finish shading in the horns, ears, and the shadow below the chest. Notice how the horns and ears are asymmetrical. This creates a sense of movement and also a sense of unease, which makes all the difference in this case.

◄ Step Seven Now that we've given this angel demonic depth through shading, we'll accentuate his frenetic emotion by adding thick, throbbing veins across his forehead.

24

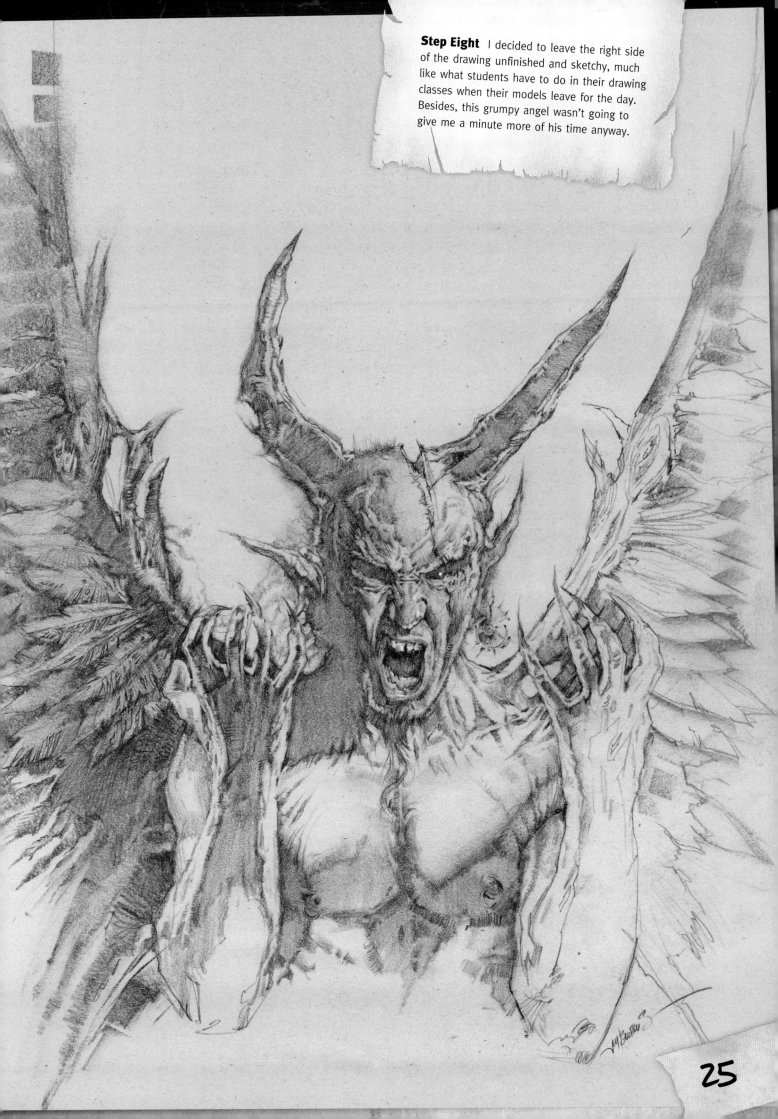

Step Eight I decided to leave the right side of the drawing unfinished and sketchy, much like what students have to do in their drawing classes when their models leave for the day. Besides, this grumpy angel wasn't going to give me a minute more of his time anyway.

25

angels depicted in art

An Overview

What better subject to render in art than one that's described in folklore and religion but completely open to interpretation. After all, no living human can say for certain what its characteristics are. Angels, archangels, seraphim, and cherubim, and lest we forget, their demonic counterparts, have provided artists with inspiration for paintings and sculpture for centuries. The results of this guiding light, so to speak, are invaluable, because every new piece of artwork essentially gives eternal life to the long tradition of angelology.

Nearly every sect around the world, including Buddhist, Hindu, Taoist, Sumerian, Zoroastrian, Egyptian, Judaic, Christian, and Islamic faiths, have used the iconography of angels to teach and uplift. It's considered spiritually sensitive matter, worthy of being protected in holy structures so that worshippers can regard the angelic artwork and walk away feeling hopeful.

Although the appearance of angels is certainly up for debate, there is a longstanding assumption in folklore and the art world that specific choirs of angels wear or carry distinct symbols. Seraphim, the highest choir of angels, each wield a fiery sword and have six red wings, whereas cherubim possess two blue wings. Thrones, the third choir of angels, are represented as having two wheels, blueish-green in color; four faces, including that of a man, a lion, a calf, and an eagle; and four eye-filled wings. Dominations are often depicted as being swathed in a floor-length gown adorned with a green stole; a golden belt cinches the gown. In their right hand, they clench a golden staff, and in their left, the seal of God. Virtues, the sixth choir of angels, tend to be illustrated as a group of brilliant figures that radiate light. Principalities, the two-winged angels who guard religions, nations, and leaders of the world, are commonly described as wearing military garb with golden belts. Likewise, archangels and angels, situated in the eighth and ninth choirs, appear as soldiers in art, and bear spearheaded javelins.

Of course variations on the theme are abundant. In Western art, for instance, dominations may be appear more regal, wearing crowns and holding scepters or orbs. Cherubim are sometimes painted holding books that symbolize their vast knowledge. A popular motif that has permeated popular culture in the modern era is the angel in priestly attire, bearing the cross, and holding some form of string instrument. If the piece of artwork showcases the archangel Michael, he's usually young, with handsome looks that border on beautiful, and mighty, with a sword, shield, and magnificent wings protruding from his shoulders. Gabriel, second in command below Michael, is portrayed as an androgynous robed beauty whose angelic accessories are a crown and a lily, which, in the Bible, he presents to Mary upon revealing her impending birth to the son of God. Raphael, the guardian angel of travelers, is commonly painted wearing sandals and a belt holding supplies in images that cast him as a fellow pilgrim. In renderings that depict him as a guardian angel, he bears a sword in one hand and is magnificently robed. One of the most popular representations of Uriel, who John Milton refers to as Regent of the Sun, shows a flame emanating from Uriel's palm.

For every inspirational painting or sculpture of a winged, haloed spirit, there's an utterly disturbing artistic representation of a fallen angel in the guise of a devil or demon intended to instill dread in the hearts of both the faithful and faithless. Demons assume grotesque human identities with abhorrent characteristics ranging from horns to bat ears. They're sometimes even portrayed as humans of great beauty, both winged and wingless—all the better to lure unwitting mortals into dubious situations.

In a miniature painting that adorned a prayer book made for the Duke of Berry early in the 15th century, angels fall downward, smoke trailing behind, as each prepares to plunge into the underworld. Lucifer, in the foreground, is the first to enter hell. And as he does, we're made aware of his beauty, which likely contributed to his bold rejection of God's rule. Painter and founder of the Sienese School Duccio di Buoninsegna recounted the temptation of Christ on canvas between 1308 and 1311. In this work, the devil is an athletic-looking dark winged angel gesturing toward the kingdoms of the world below. Satan is also portrayed, quite literally, as the Prince of Darkness in Giotto's fresco of the Pact of Judas (also painted in the 14th century). Black from head to toe, he clings to Judas's shoulder from behind with spindly fingers and malicious intent.

One of the more unnerving depictions of fallen angels' work in hell is 15th-century Flemish artist Hans Memling's painting of demons inflicting torture upon the damned, who, naked and powerless, attempt to reach out as they are knocked farther into the depths of the inferno. The dark demons wield spears and clubs as their clawed feet grip the necks and backs of victims cursed into submission.

The motive behind these horrifying images is undeniably moral. Although many were based on the artists' interpretations of scripture or lore, or simply conceived of by their vivid imaginations, pieces of art that depict hell and its servants are intended to stir the soul and warn us that the agony of hell is good reason to avoid it at all costs.

forbidden love

With shimmering wings and the purest of hearts, our Good Angel should be able to thwart the evil intent of her seducer. But based on her submissive position, it's obvious whose power will prevail. The subtle nuances of facial expression and body language in this drawing are integral to how the story unfolds.

Materials
- Vellum paper
- Black colored pencil
- Cool, 50% gray colored pencil
- Eraser
- Tracing paper
- Sheet of fine-grain sandpaper (optional)
- Photoshop® (optional)
- White gouache (optional)
- Small paintbrush (optional)

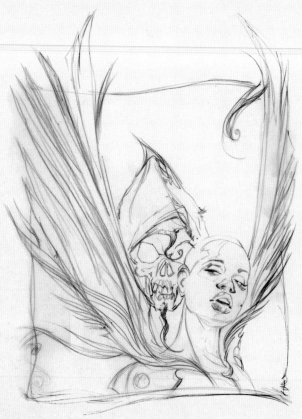

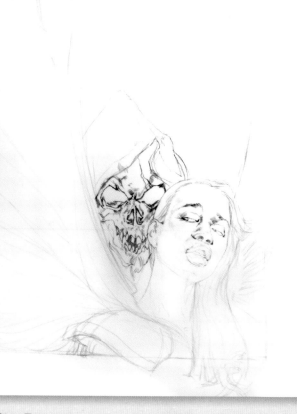

▲ **Step One** This drawing depicts Evil's seduction of Good. Notice how the beautiful angel representing goodness is positioned in the forefront, while the dark angel lurks from behind her magnificent wings, trying to seduce her with his lurid kiss. To begin this image, create a rough thumbnail using a black colored pencil over tracing paper. Next, do a quick linear drawing using the side of the pencil for the wings to indicate their soft texture.

▲ **Step Two** Now we'll start the finished drawing on vellum paper. Because this will be a tight, finished piece, we're using several different values of gray colored pencils, in addition to black. An effective way to achieve the desired values is simply to switch pencils. Here, we begin with a cool, 50% gray colored pencil for the linear drawing. The wings encompass both angels and act as a natural frame.

◄ **Note:** It's extremely important to keep your pencils sharp, especially when drawing at this size and when using vellum paper. It's best to use an electric sharpener that produces very sharp tips (preferably to a 16-degree point). Next, you can use 600-grit sandpaper to further sharpen the pencil. This also creates a chiseled edge which makes it easier to vary the width of your line as you draw.

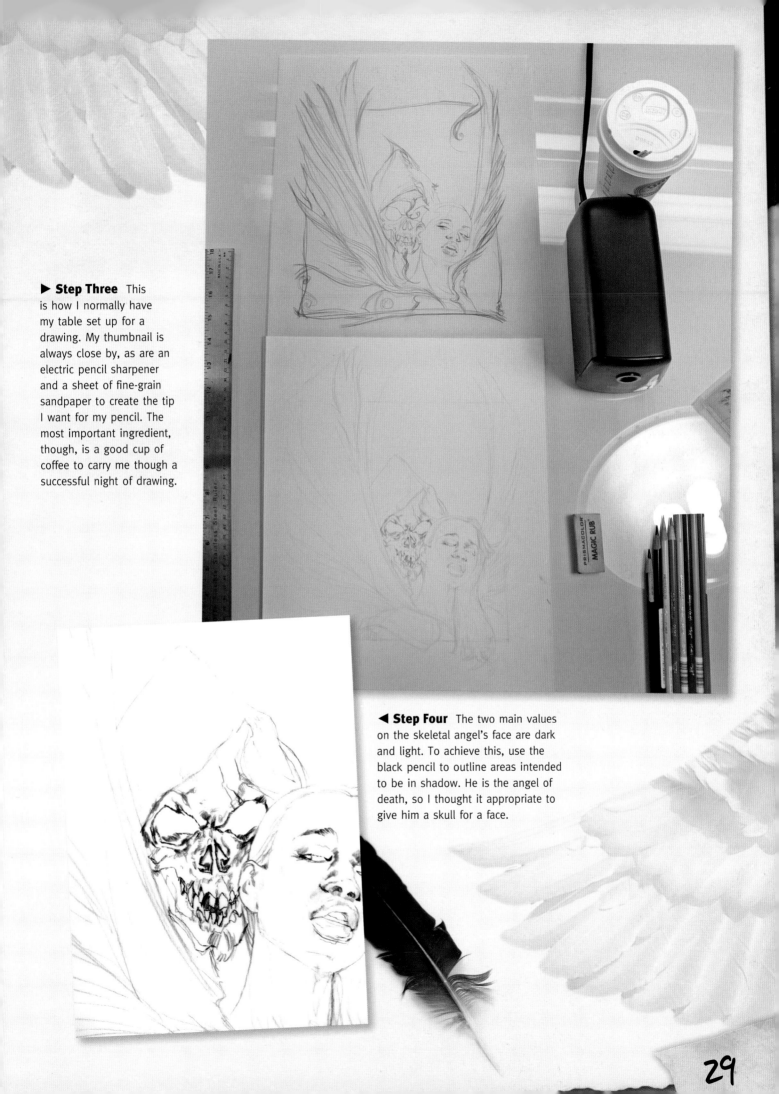

▶ Step Three This is how I normally have my table set up for a drawing. My thumbnail is always close by, as are an electric pencil sharpener and a sheet of fine-grain sandpaper to create the tip I want for my pencil. The most important ingredient, though, is a good cup of coffee to carry me though a successful night of drawing.

◀ Step Four The two main values on the skeletal angel's face are dark and light. To achieve this, use the black pencil to outline areas intended to be in shadow. He is the angel of death, so I thought it appropriate to give him a skull for a face.

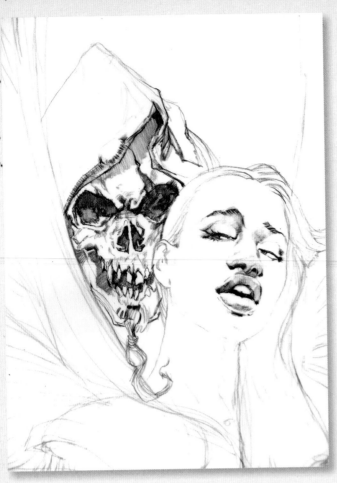

◄ Step Five Now we'll begin to address the mid-values of the faces. The girl should appear soft and sensual, so try to keep the pencil strokes consistent and smooth. Conversely, the strokes on the evil angel should be more chiseled and obvious.

► Step Six Notice that even the smallest, softest strokes on each face are deliberate and designed. This serves two purposes: It describes the form of the anatomy and creates a strong, alluring drawing.

◄ Step Seven The angel of death isn't very attractive by most standards, but with several hundred years of practice, he's certainly mastered the art of seduction. To show that he is close to succeeding with his innocent victim, I kept her eyes almost completely closed and her full lips slightly parted in pleasure. Note that her eyebrows are raised toward the center, to show that a small part of her struggles with this unwanted, intrusive desire. Remember: The feeling is in the detail.

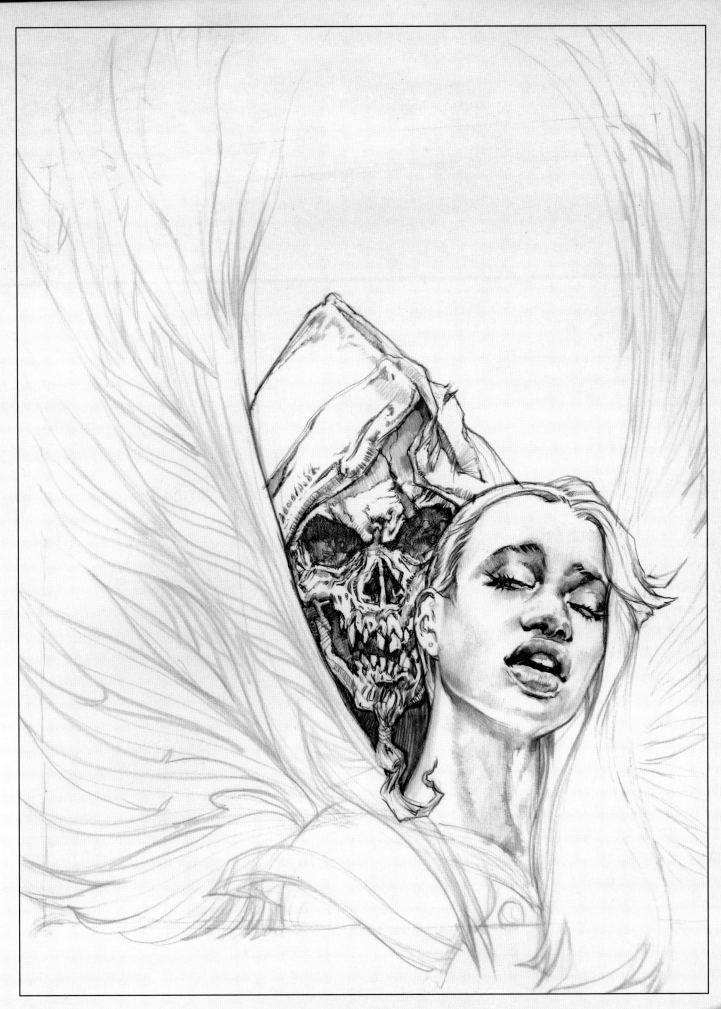

Step Eight The wings are arched so that they envelope both angels. This detail draws the viewer's attention to their faces while simultaneously creating an elegant frame. Try to keep the lines curved and soft, almost like the flame of a candle.

▶ **Step Nine** Now, make our evil seducer even more menacing by using pencil strokes to add dark accents in the crevices of his eyes, nasal passages, and mouth. The pupils within his eye sockets show that he isn't made up of just dry, brittle bones. And the shapes within the skull exaggerate his expression and his age.

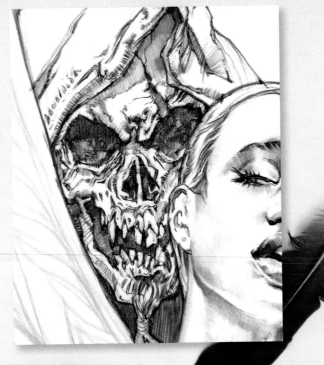

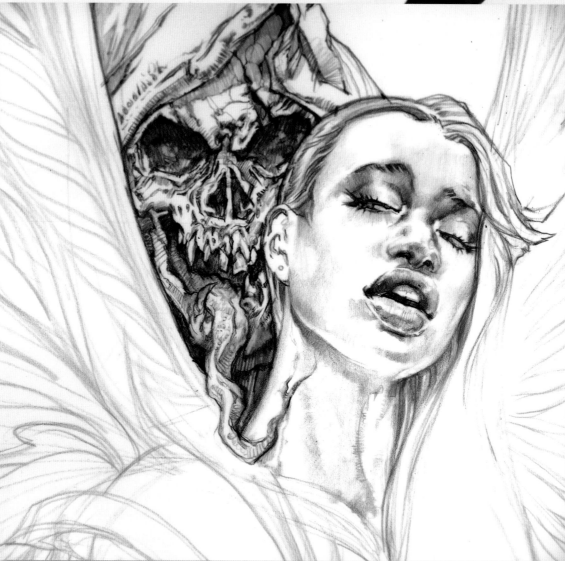

Step Ten As you can see, I changed the evil angel's goatee into a serpentine tongue, as he's supposed to be seducing his victim, not tickling her. To achieve this, I knocked out a couple of his bottom teeth and made the back of his tongue a darker value. Then I split the tongue in two, like a snake's.

▶ Step Eleven After completing the faces, revisit the wings. To give the girl's wings a whimsical, magical effect, create soft swirls and shapes within them. Let your imagination be your guide as you design these patterns. Just be sure that the patterns follow the form of the feathers.

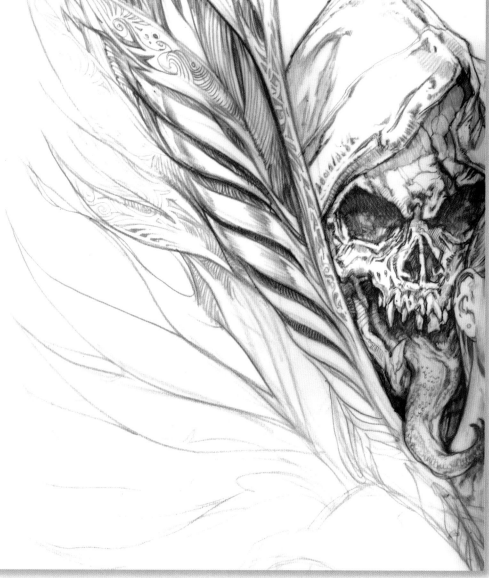

◀ Step Twelve The design of her shoulder pad is reminiscent of that on her wings. Remember that it's important to keep the shapes for her and her costuming clean and more graphic to contrast with the complexity of the bad angel behind her.

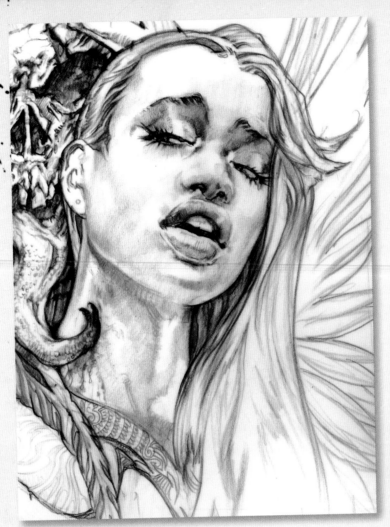

◀ **Step Thirteen** Here, be consistent with the previous steps and keep her hair graphic. Use a few simple shapes and make them quite chiseled to offset her soft, sensuous features.

▶ **Step Fourteen** Next, create the effect of pushing the evil angel farther into the background by darkening his hood.

◀ **Step Fifteen** In this step, we're going to give the good angel's shoulder pad a chrome finish, as if she's wearing protective armor. To create the metallic texture, shade in a dark core shadow down the middle. This shadow shape has to be broken up to illustrate that it is reflecting its environment. Next, give the entire shoulder a mid-value. Then, use your eraser to create a bright highlight down the middle of the medium value. And voilà—you have your chrome finish.

34

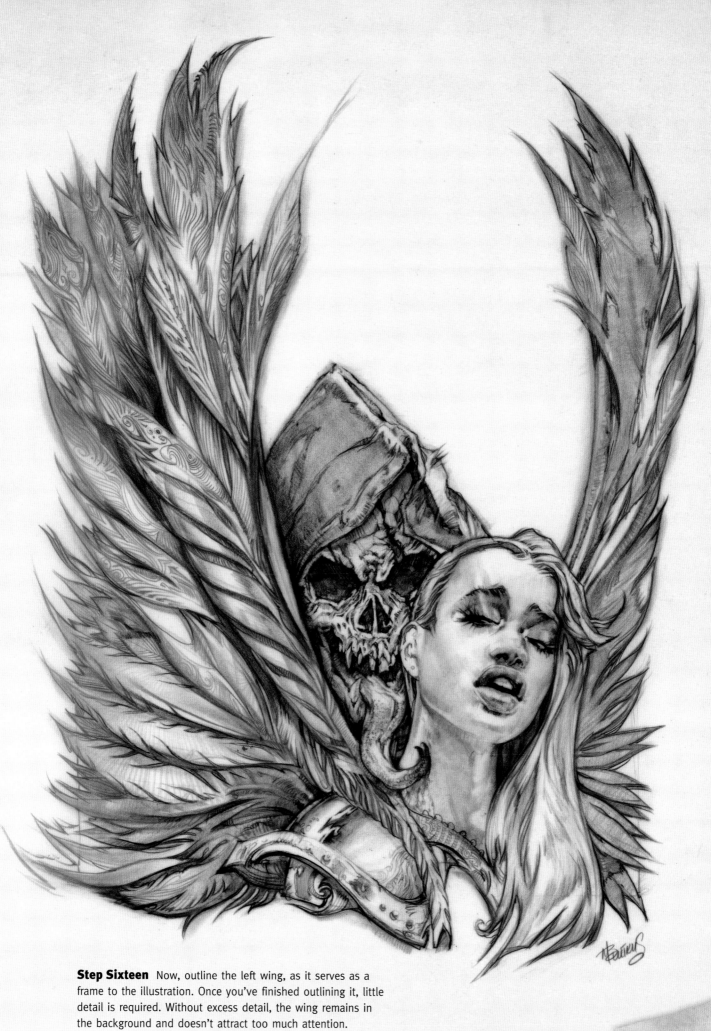

Step Sixteen Now, outline the left wing, as it serves as a frame to the illustration. Once you've finished outlining it, little detail is required. Without excess detail, the wing remains in the background and doesn't attract too much attention.

35

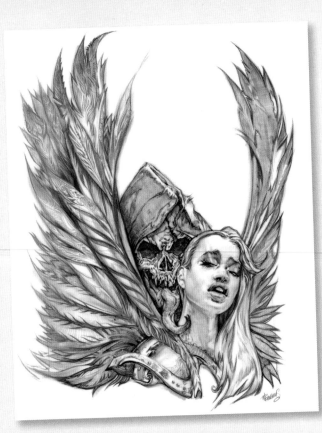

▲ **Step Seventeen** If you want to enhance your drawing digitally, scan it into Photoshop®. Here, we'll brighten the highlights, deepen the shadows, and add some sparkle to the good angel. First, choose the eraser tool and select the appropriate brush diameter. Then, lower the hardness and opacity level to about 50%. From here, go over all the pre-existing highlights on the faces, hair, and shoulder.

▶ **Step Eighteen** Now for the sparkles! I thought the shimmering light that good angels are known for was perfect for this young, naïve angel. To start, choose the eraser tool, keeping the diameter small and the opacity at about 85%. Then, create each sparkle individually by varying the diameter to prevent the overall effect from appearing too contrived. Next, select the dodge tool, increase the brush size to about 30px, and bring the hardness down to zero. Choose "highlights" as the range, and keep the exposure to around 20%. Using the dodge tool, go over the wings and the girl to create the glow in the illustration.

▶ **Step Nineteen** In this final step, we'll darken some areas to give the illustration more dimension. Begin by choosing the burn tool and choosing the appropriate diameter (whichever setting is comfortable for you). I kept the hardness to a zero and changed the range to "midtones." Then, use the tool to darken certain areas on the wings to emphasize the fullness and depth of the layers. You can also use the burn tool in any area that could benefit from a darker value, like the side of the girl's face and sections of the hair. It isn't necessary to use Photoshop for this illustration. The mounting process used for the cover art (see page 74) will achieve the same effects. In that case, use a little bit of white gouache, water, and a fine brush for the bright highlights. Photoshop, however, is far more expedient when trying to meet a deadline.

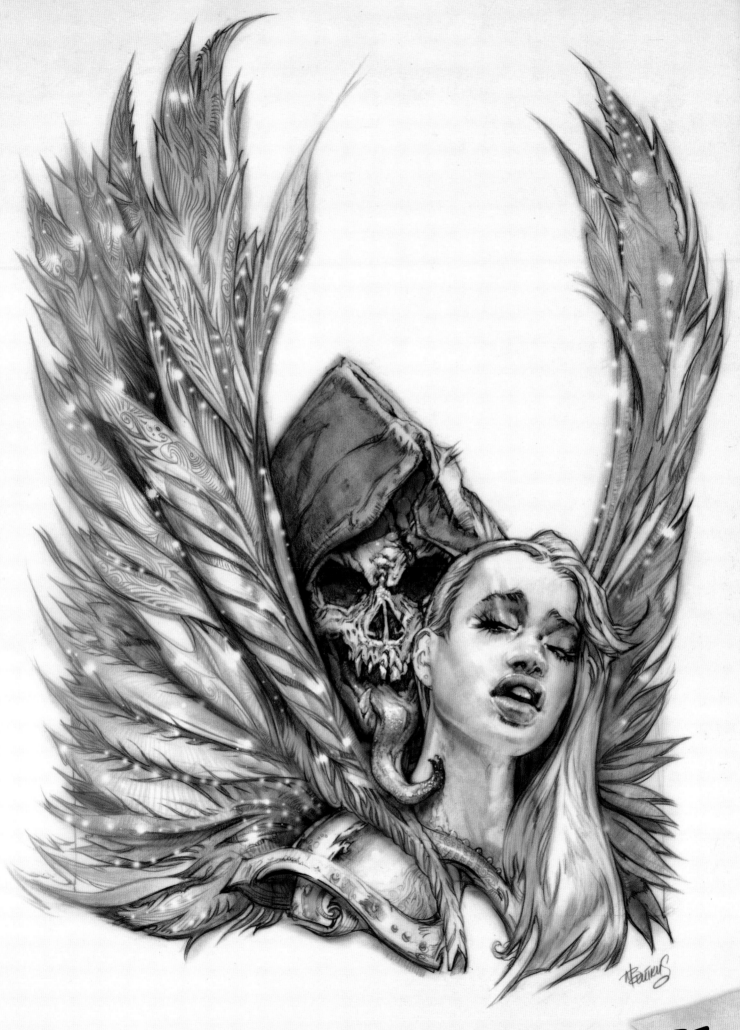

37

fallen angel movie poster

These ghouls, goblins, and an angel with deceptively good looks have emerged from the fiery pit of hell to grace a silver screen near you. It's the film Satan wants everyone to see. And this is the movie poster that will lure thousands of unsuspecting do-gooders to the dark side.

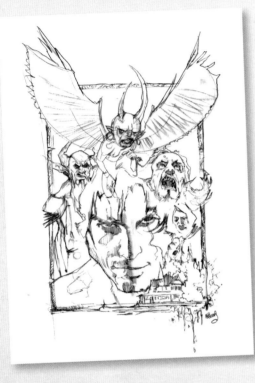

◀ **Step One** Before beginning a comprehensive sketch for a black-and-white movie poster, it's important to read the script to familiarize yourself with the plot, characters, and mood of the movie. If there isn't a real script, do as I did. Create a campy illustration filled with ghouls, monsters, and, of course, our leading man, the fallen angel.

▶ **Step Two** When you've decided upon the mood, the next step is to create a cast of characters and do a preliminary sketch using a black colored pencil over tracing paper. This design pays tribute to movie posters of the 1960s and 1970s, which commonly featured a montage of the movie's main characters. The portrait of the sinister angel looms large in the center, while various creatures of the night surround him. For inspiration in creating your own cast of characters, research creature designs from favorite artists. You can also take photographs of people and exaggerate or distort their features.

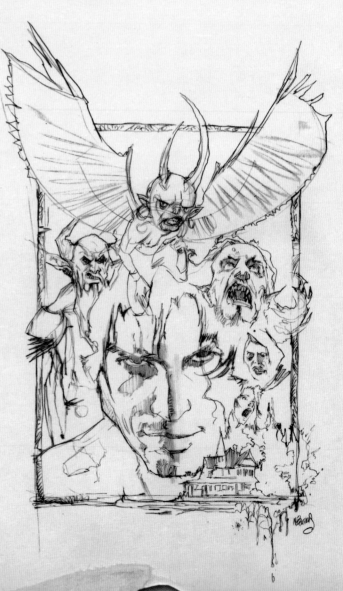

38

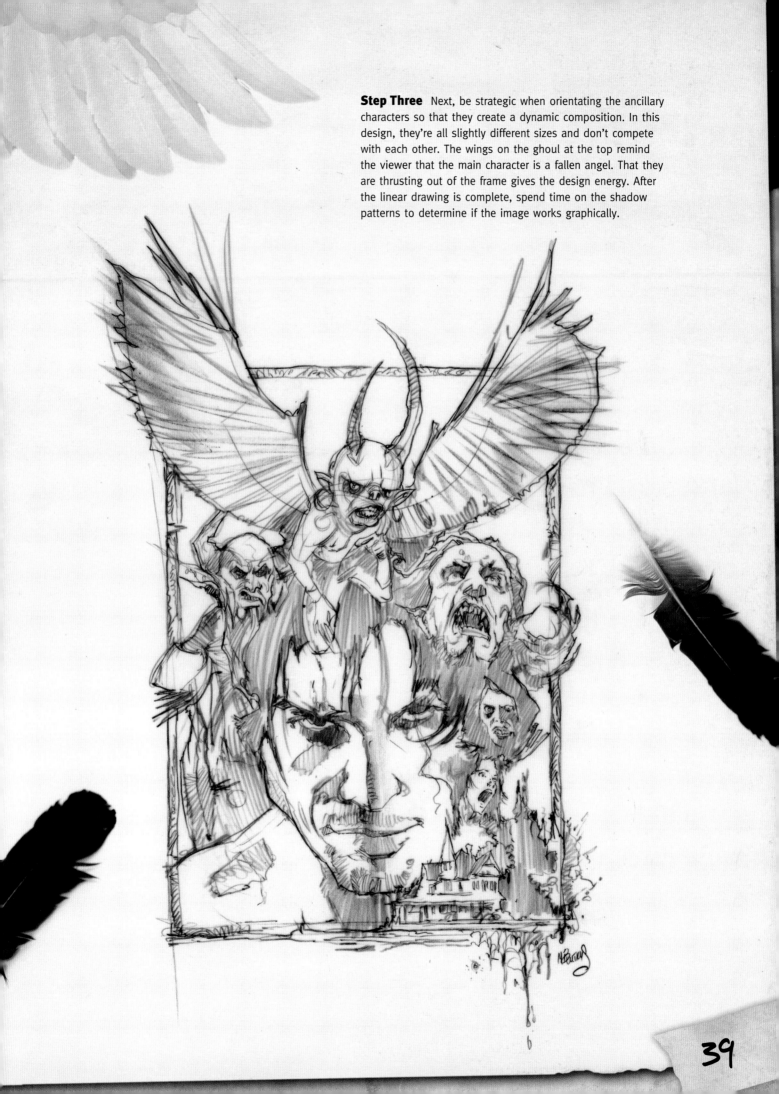

Step Three Next, be strategic when orientating the ancillary characters so that they create a dynamic composition. In this design, they're all slightly different sizes and don't compete with each other. The wings on the ghoul at the top remind the viewer that the main character is a fallen angel. That they are thrusting out of the frame gives the design energy. After the linear drawing is complete, spend time on the shadow patterns to determine if the image works graphically.

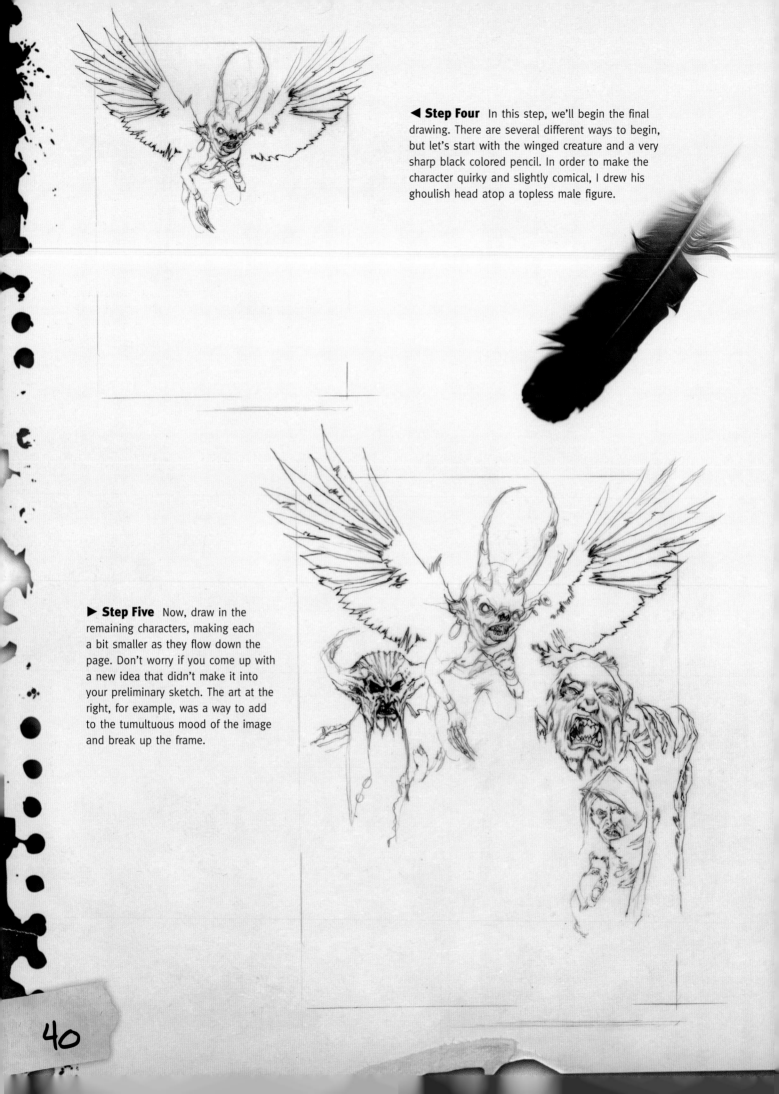

◄ Step Four In this step, we'll begin the final drawing. There are several different ways to begin, but let's start with the winged creature and a very sharp black colored pencil. In order to make the character quirky and slightly comical, I drew his ghoulish head atop a topless male figure.

► Step Five Now, draw in the remaining characters, making each a bit smaller as they flow down the page. Don't worry if you come up with a new idea that didn't make it into your preliminary sketch. The art at the right, for example, was a way to add to the tumultuous mood of the image and break up the frame.

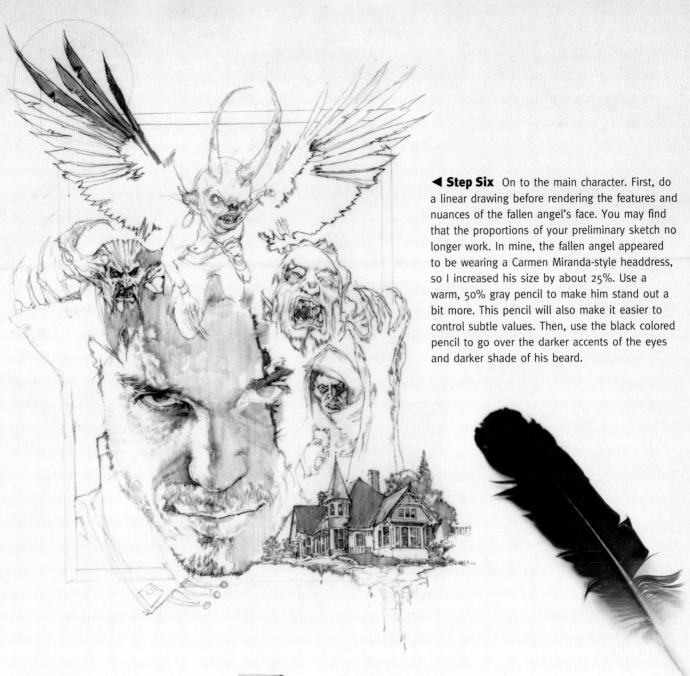

◄ Step Six On to the main character. First, do a linear drawing before rendering the features and nuances of the fallen angel's face. You may find that the proportions of your preliminary sketch no longer work. In mine, the fallen angel appeared to be wearing a Carmen Miranda-style headdress, so I increased his size by about 25%. Use a warm, 50% gray pencil to make him stand out a bit more. This pencil will also make it easier to control subtle values. Then, use the black colored pencil to go over the darker accents of the eyes and darker shade of his beard.

► Step Seven The haunted house was pieced together using various architectural photos. The most important things to remember when rendering realistic architecture and landscape are clean lines and accurate perspective. Notice that the shapes of the windows and crevices are varied, and that I've added some creepy foliage to the environment. To avoid detracting attention from the main focus of the poster, keep the changes in values at a minimum. Also, keep the shading consistent. Using the cool, 50% gray colored pencil for the house will ensure that the value doesn't become too dark.

▶ Step Eight Continue to use the cool, 50% gray colored pencil to shade in the large shadow patterns of the secondary characters. Try to vary the direction of the line quality and strokes to give the image movement and draw attention to their costumes. I exaggerated their snarls and grimaces, but not to the extent that attention is drawn away from the angel.

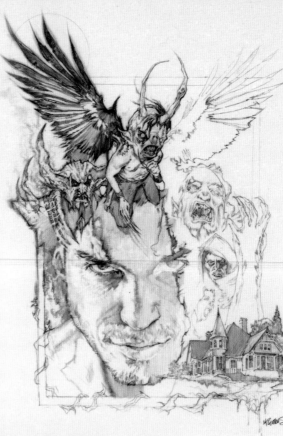

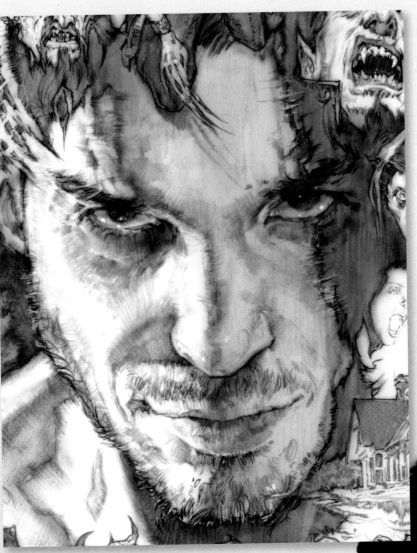

◀ Step Nine In this step, we'll complete the remainder of the face. Use the warm, 50% gray colored pencil to define his features with short, even strokes. Using wavy lines for the facial hair distinguishes them from the other lines. Then, go over the scar, accents of the eyes, and the beard with the black colored pencil to add depth to the drawing.

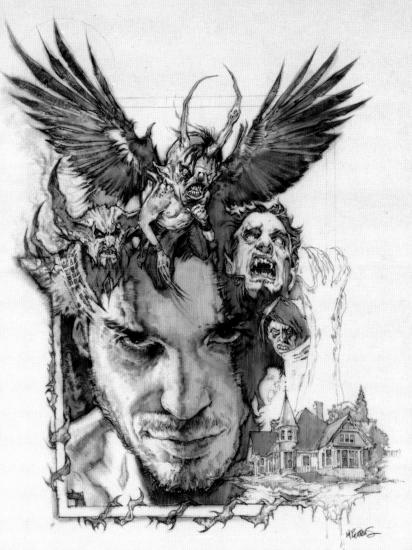

▶ **Step Ten** Continue to work your way down through the rest of the characters. They should remain mostly in shadow, and their value changes should be kept to a minimum. Remember to keep the core shadows strong and the shading consistent. Use the black colored pencil for the shadow areas. Then, create highlights with the corner of an eraser to complete them. For the border, I drew in thorny ivy to break up the angularity of the frame.

◀ **Step Eleven** The moon behind the wing makes the overall mood and composition of the poster more dramatic. Use a cool, 30% gray colored pencil to make the moon more powerful. Then, use your eraser to create the mist that engulfs it.

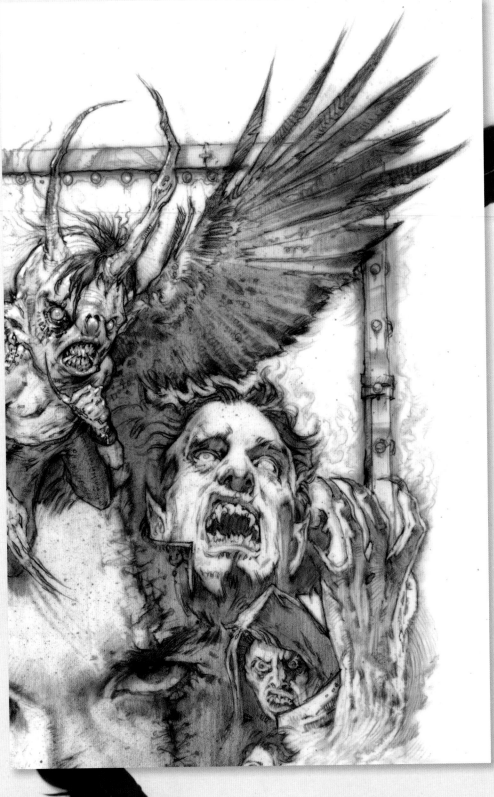

◄ **Step Twelve** For the hand at the right, use the black colored pencil for the top half. Then, switch to the cool, 30% gray colored pencil for the wrist. This ensures a nice transition from the hand into the foggy environment. You can use a lighter pencil for the flames (or clouds, depending upon how you look at them) in the background.

▶ **Step Thirteen** In this final step, we'll make some minor adjustments. Begin by brightening all the highlights and the rim lighting with an eraser. Then, soften some edges, particularly around the bottom of the frame and the core shadow of the forehead. Do this by lightly pulling the eraser back and forth across the drawing. At this stage, the drawing would be ready for the director's approval. Once approved, you'd do a tight colorized comprehensive sketch, before turning over the final movie poster illustration.

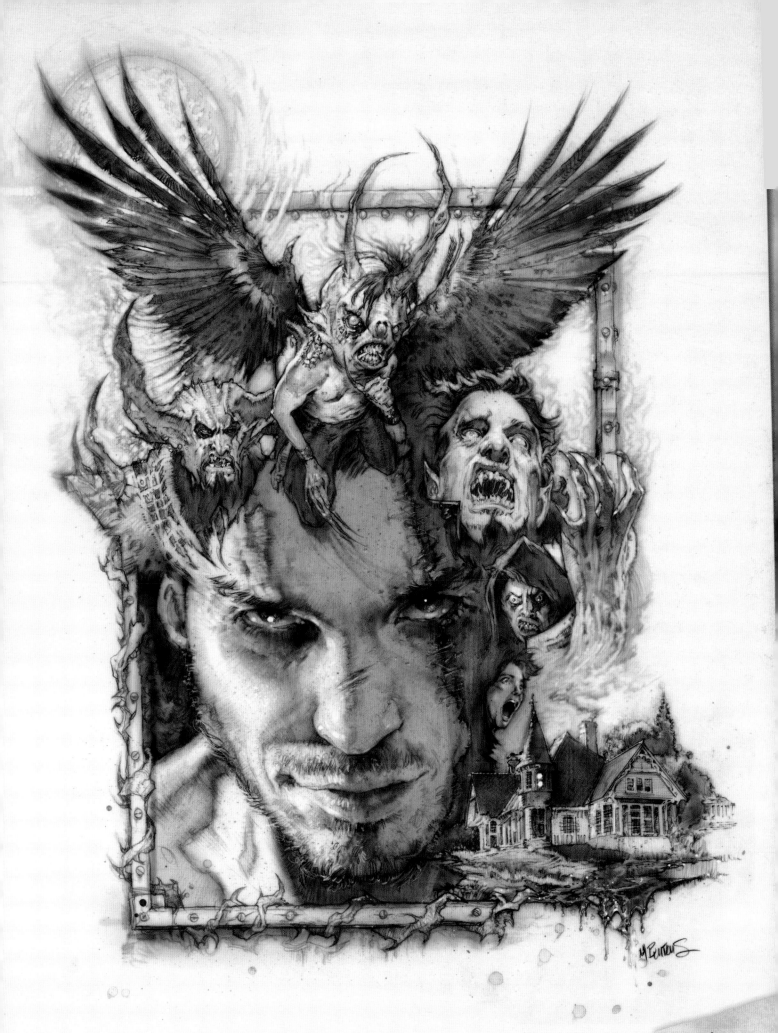

45

good angel / bad angel

The Guardian Angel

The unanswered questions that complicate the supposed existence of guardian angels makes these favorite subjects of art and lore all the more alluring. If they do really exist, do all mortals have individual angels assigned to them who will ensure their well-being? If so, why do bad things still happen to good people? Curious angel enthusiasts also ponder from which level of angels guardians hail, and whether human beings are granted their protection as soon as they're born into the world.

Many theologians refer to the sacred teachings of the Bible when defending the notion that guardian angels exist. Psalm 91:11–12 says: "For He shall give His angels charge over thee, to keep thee in all ways. They shall bear thee up in their hands, lest thou dash thy foot against a stone." But there are plenty who have argued that the evidence isn't all together convincing, which isn't unjustified considering the passage in Psalms is one of two in the Bible that alludes specifically to the existence of guardian angels.

John Calvin was one naysayer who believed it was more likely that a host of angels bands together to oversee mankind's salvation than one angel being tasked with the duty of safeguarding all, or that each individual is assigned one guardian spirit to guide him or her through life. If there is, in fact, a guardian angel designated for each person on earth, and if guardian angels are drawn from the lowest rank of the nine orders of angels, that would mean that heaven has an inordinate amount of angels—a population that far surpasses the human population on earth.

There is also great mystery surrounding the appearance of guardian angels as they manifest themselves in the world of the living. Theologians concur that the shapes angels assume as they carry out their holy orders on earth aren't living, breathing entities, although by many accounts, they can be entirely convincing. They mimic human form but lack the ability to perform the vital functions that humans can.

Whether or not these transformative spirits also look after non-Christians has generated debate among theologians for centuries, but followers of the New Age movement feel certain that everyone has a spirit guide—an otherworldly guardian that can be accessed through the appropriate forms of channeling. The New Age set are less likely to call these helpers angels, however, favoring "guides" as a more secular description of the concept. Unlike guardian angels, spirit guides can be used to make contact with the dead, and they are more likely to provide assistance than rebuke humans for past or imminent sins.

The Rebel Angel

Cartoons and movies have long depicted protagonists hanging in the balance between good and evil as a good angel, haloed and all smiles, whispers in one ear, and a bad angel (or sometimes devil), whispers in the other with one eyebrow cocked and wearing a malevolent grin. Here we have the pop culture rendition of the opposing forces that hail from the realms sandwiching the human world but are said to walk the earth among men: the guardian angel and the rebel angel. But pop lore is probably where this notion of each person having a good angel and bad angel ends. Although lay theologian and novelist C.S. Lewis illustrated in *The Screwtape Letters* his belief that each human is assigned a demon with the sole purpose of fueling temptation, there is no reference in the Bible to such a thing. Good old John Calvin weighed in, in the 16th century, chalking up the concept of personal *bad* angels to imaginations gone wild.

That each person probably doesn't have a so-called spirit guide and an evil guide that add up to anything more than one's own conflicted mind doesn't mean rebel angels don't enter human territory with the primary goal of undoing all the good that guardian angels have done. Until the second coming of Christ in Christian tradition, demonic activity continues to plague the earth in the forms of temptation; possession; obsession; and myriad occult-related activities, including black magic and divination. Second Corinthians tells Christians that not only does Satan disguise himself as an angel of light, but that members of his demon legion also take on the appearance of righteous servants.

Lucifer's obsession with power in heaven and his subsequent fall from grace is an allegory used to warn powerful, knowledgeable people against misusing their gifts in a way that will bring about evil and suffering. In that context, like Lucifer, we are all really rebel angels in the making. The majority of us have the capability to rise up and achieve greatness. It's our decisions when we do that decide the state of our soul.

be mine

Not even the Grim Reaper can resist the charm of an adorable angel warrior. Wearing his dead heart on his sleeve is clearly not enough. Only a fresh, steaming heart will do for the girl of his dreams. In this project, you'll learn how the grotesque can be cartoonish, and how a little bit of color can make a heart come alive.

Materials
- Vellum paper
- Black colored pencil
- Eraser
- Tracing paper
- Photoshop® (optional)

◄ **Step One** Start off this campy but creepy illustration by doing an assortment of preliminary sketches. By doing this, you can get a feel for the characters and their cartoonish style. Experiment with body language and different expressions to see what works best together.

▶ **Step Two** Here, the preliminary sketches are pared down to a love-struck Grim Reaper vying for the attention of an elfin angel cutie. At this point, it's necessary to work out the body position to make sure the two characters work compositionally.

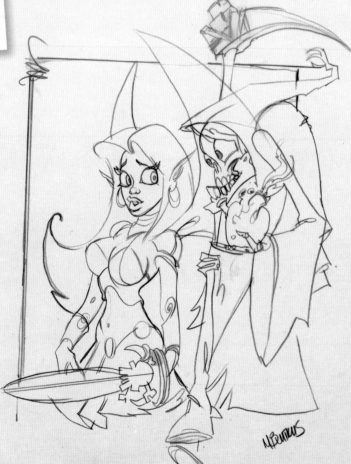

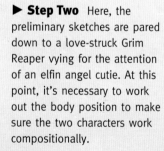

48

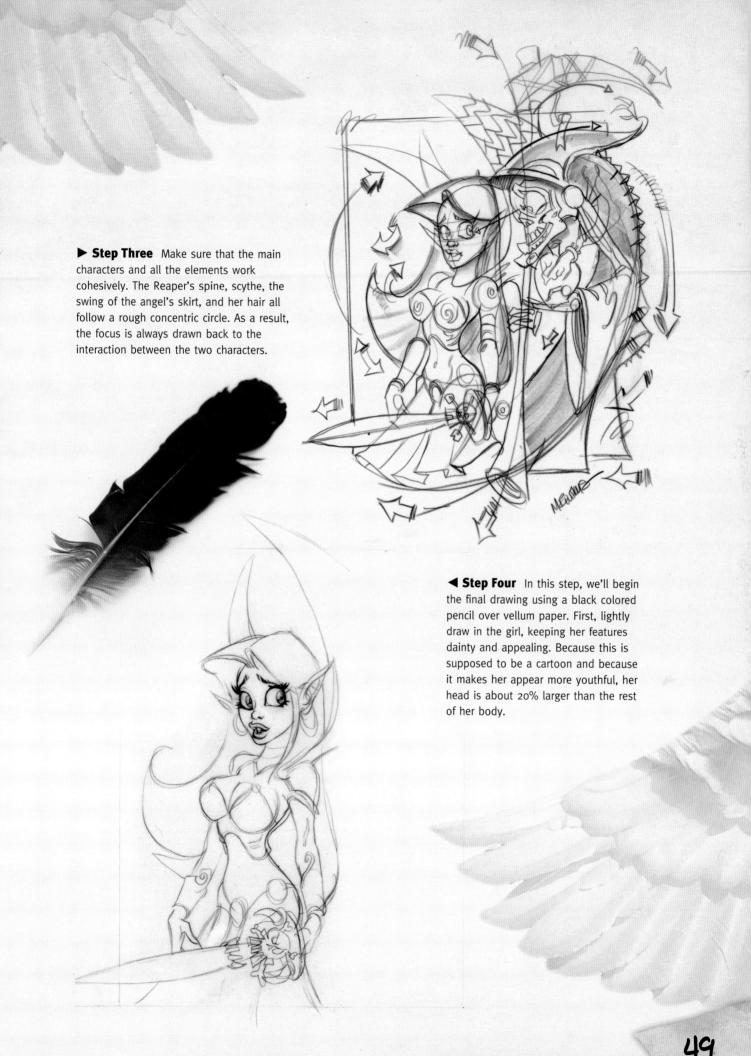

▶ **Step Three** Make sure that the main characters and all the elements work cohesively. The Reaper's spine, scythe, the swing of the angel's skirt, and her hair all follow a rough concentric circle. As a result, the focus is always drawn back to the interaction between the two characters.

◀ **Step Four** In this step, we'll begin the final drawing using a black colored pencil over vellum paper. First, lightly draw in the girl, keeping her features dainty and appealing. Because this is supposed to be a cartoon and because it makes her appear more youthful, her head is about 20% larger than the rest of her body.

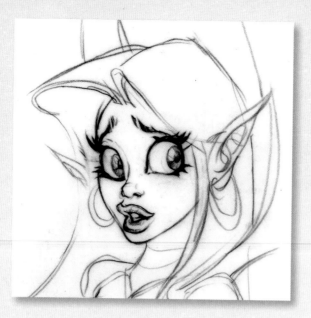

◄ Step Five Now, let's work on her face. Start by outlining her features in a darker value. Not much more than a bit of tone and a few highlights is required. She should look young and pretty, so the less you do, the better.

► Step Six Continue by shading in her hair, following the direction of its flow. Keeping the bottom edges soft suggests movement. Notice how the designs on her skimpy armor are kept curvy and feminine.

◄ Step Seven Next, give this Grim Reaper his goofy personality. I made his eyes large and myopic as he ogles the beautiful angel. Then, I drew an exaggerated lower jaw that juts way out to give him a dopey grin. He is drawn larger than the frame to break up the straight edge.

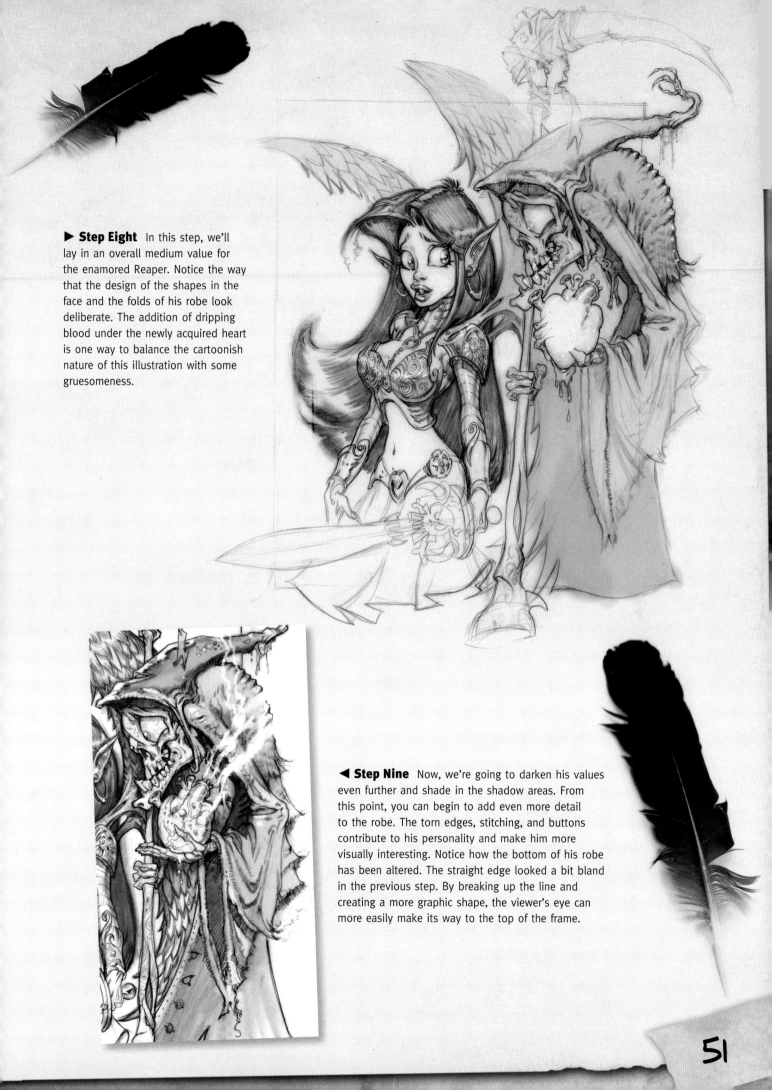

▶ **Step Eight** In this step, we'll lay in an overall medium value for the enamored Reaper. Notice the way that the design of the shapes in the face and the folds of his robe look deliberate. The addition of dripping blood under the newly acquired heart is one way to balance the cartoonish nature of this illustration with some gruesomeness.

◀ **Step Nine** Now, we're going to darken his values even further and shade in the shadow areas. From this point, you can begin to add even more detail to the robe. The torn edges, stitching, and buttons contribute to his personality and make him more visually interesting. Notice how the bottom of his robe has been altered. The straight edge looked a bit bland in the previous step. By breaking up the line and creating a more graphic shape, the viewer's eye can more easily make its way to the top of the frame.

51

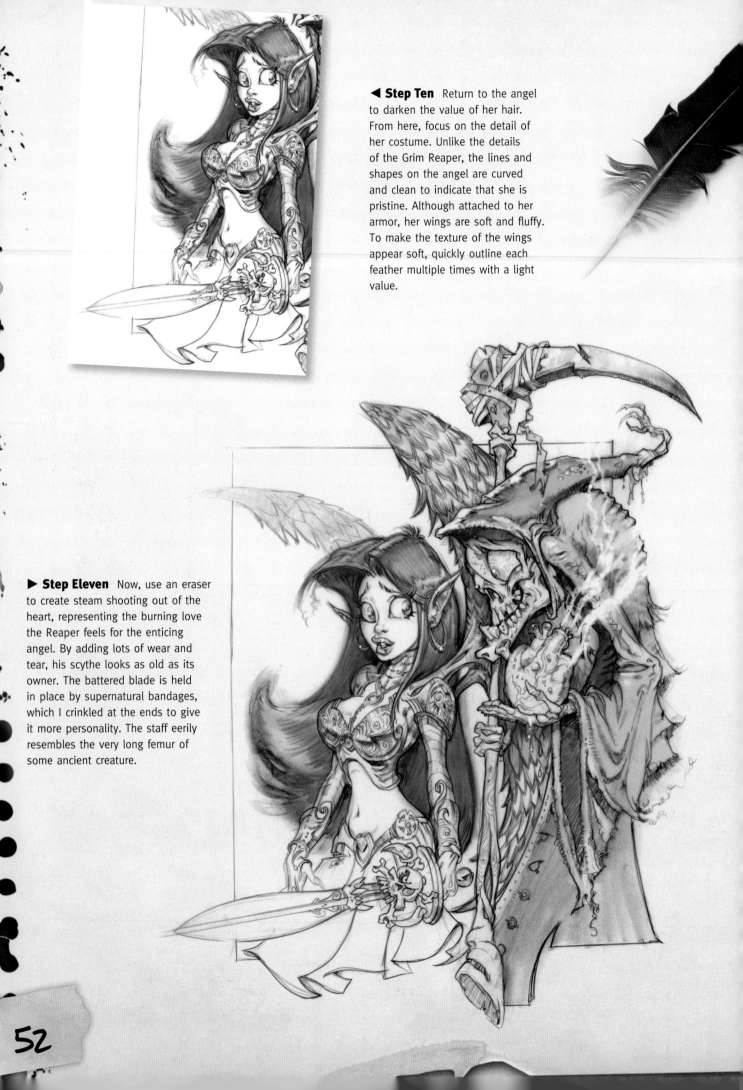

◄ Step Ten Return to the angel to darken the value of her hair. From here, focus on the detail of her costume. Unlike the details of the Grim Reaper, the lines and shapes on the angel are curved and clean to indicate that she is pristine. Although attached to her armor, her wings are soft and fluffy. To make the texture of the wings appear soft, quickly outline each feather multiple times with a light value.

► Step Eleven Now, use an eraser to create steam shooting out of the heart, representing the burning love the Reaper feels for the enticing angel. By adding lots of wear and tear, his scythe looks as old as its owner. The battered blade is held in place by supernatural bandages, which I crinkled at the ends to give it more personality. The staff eerily resembles the very long femur of some ancient creature.

▶ Step Twelve Let's jazz up the Reaper's robe even more. He's trying to impress the girl of his dreams, after all. To make the robe look like it was once made of plush, embroidered fabric, use a light hand to draw patterns of tightly knit swirls. Then, shade his entire robe a couple values darker.

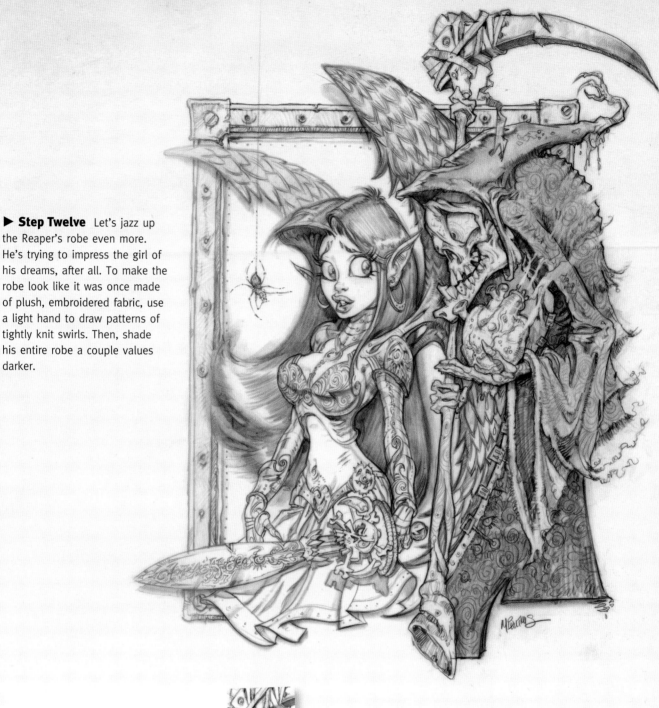

◀ Step Thirteen There's a lot going on in the edges of the drawing. The straight edge frame helps balance the wings, the scythe, and the clothes. To make it look solid and sturdy, I drew bolts around it. Next, I gave the inside of the frame a darker value for depth. Sometimes negative space is begging for an element. The space between the angel and frame looked empty, and the creepy, spindly spider was just the thing to fill it.

▲ Step Fourteen The angel's skirt has a sheen to it, and the hem has tiny stitching so that the fabric looks metallic. This effect helps it harmonize with the top she's wearing. The graphic and angular nature of the skirt's hem creates a solid border treatment for the bottom. For the sword, I designed exotic etchings on the blade. Some shadow is shaded in beneath it to make it appear as though it's held in front of the skirt and frame.

▶ Step Fifteen To make this drawing really come alive, you have the option of scanning it into Photoshop®, where you can add more dimension.

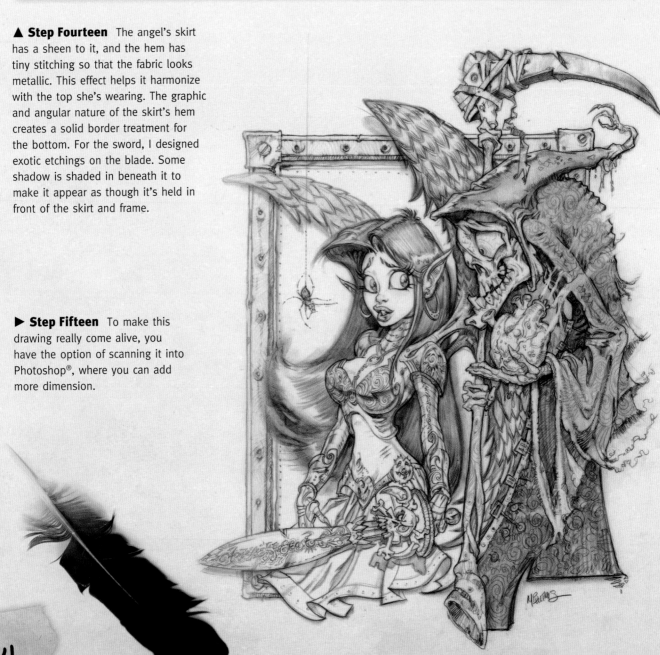

▶ **Step Sixteen** Begin by darkening the drawing in Photoshop by selecting "levels" and adjusting it to your liking. Then, choose the burn tool to darken all the shadow areas. Set the exposure to about 50% and the hardness to zero. Now, select "midtones" as the range. This adds more dimension to the illustration and brings the important elements to the forefront.

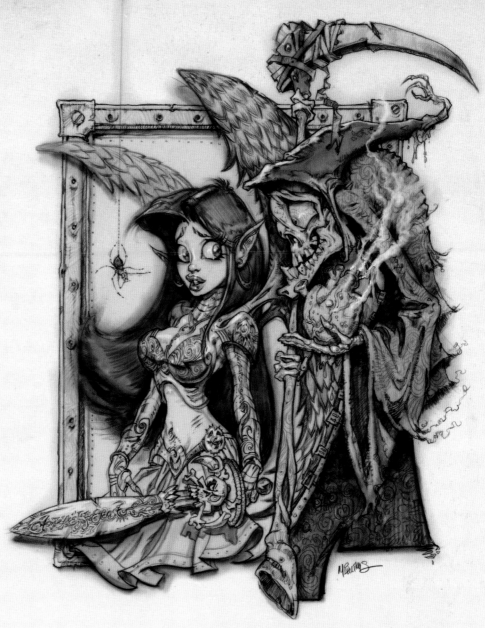

▶ **Step Seventeen** Next, we'll brighten the highlights. Select the eraser tool and adjust the brush diameter to the requirements of the area at hand. The highlights should look natural, without crisp edges. To achieve this, keep the opacity at about 50% and the hardness at zero.

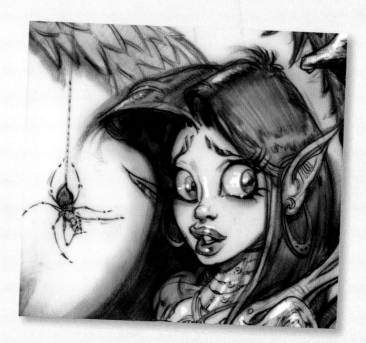

◄ Step Eighteen Now for the romantic, heartwarming gift. The heart, complete with all its values and veins, is already drawn. All that's left to do is add a bit of color.

► Step Nineteen First, select the paintbrush tool, keeping the opacity at about 50% and the hardness at zero. The "mode" should be on "multiply." Next, lay in the medium value by choosing a dark pink from the color palette. Then, paint in the entire heart. After you finish coloring in the heart, return to the palette and choose a deep red. Adjust the diameter accordingly and go over the heart again, layering paint around the perimeter of the heart to darken it, thereby making the form turn.

◄ Step Twenty To create the veins, decrease the size of the diameter of the paintbrush and choose a blue-violet color from the palette. Start painting over the veins already drawn, but feel free to add new veins or add pustules. This doesn't have to be accurate, just disgusting. Next, switch to the eraser tool and decrease the diameter even more. Keep the opacity at 50%, and create a highlight down the middle of the veins that are hit by light.

► Step Twenty-One The steam effect is achieved in a similar vein. Start by using the eraser tool in a circular motion, randomly erasing the middle of the shooting steam. Next, go back to the paintbrush tool and lower the opacity to about 20%. I chose purple for the rest of the steam because it complements the grayish-green tones of the illustration.

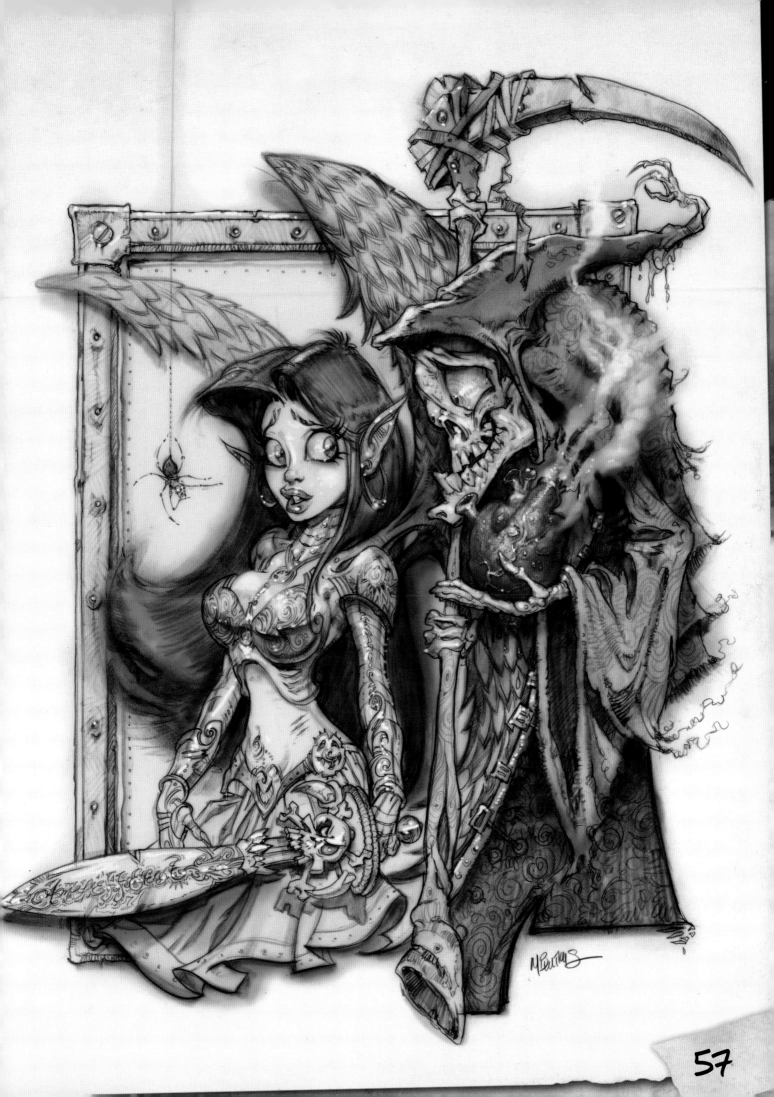

Steampunk angel

Steampunk can be described in myriad ways: Victorian-industrial with a dash of whimsy, otherworldly with a nod to the nineteenth century, sci-fi meets romance. Add an angel into the mix, and you have a winged being that can do far more than just fly. With futuristic accoutrements, he's an unstoppable force—a malevolent machine that knows no mercy.

Materials
- Vellum paper
- Black colored pencil
- Tuscan red colored pencil
- Eraser
- Tracing paper
- Photoshop® (optional)

▶ **Step One** Steampunk is one of my favorite genres to illustrate. This piece is an example of how I'd approach a production drawing for a movie that required a steampunk character. The goal is to design believable-looking technology that would enable the character to fly. Begin by doing a preliminary sketch using a sharp black colored pencil over tracing paper. Roughly place all the gadgets. Then, make the angel proudly splay out his left wing so that it's clearly visible among all the elements.

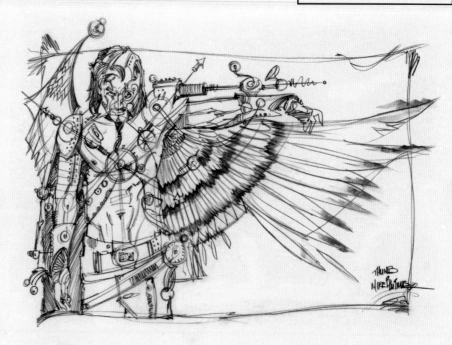

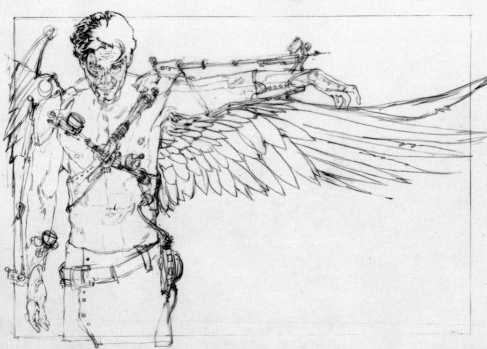

◀ **Step Two** Next, start the finished drawing using the Tuscan red colored pencil over vellum. The red pencil gives the drawing a vintage feel. Feel free to change a few things from the preliminary sketch as you see fit, as I did. Once again, I referenced a photo from the cover art shoot, mainly for the face and anatomy. Make sure that all the gizmos and weapons fit his form snugly so that they don't look like a hindrance.

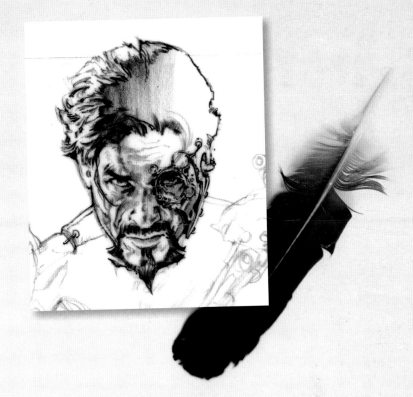

▶ **Step Three** When you achieve the effect you want with the lay-in, go back and begin to render the face. Try to keep the strokes on his face chiseled and short. I gave him a devilish goatee and an elaborate eyepiece that hooks onto his ear. I stopped there because I like the sketchy, unfinished look the drawing has right now.

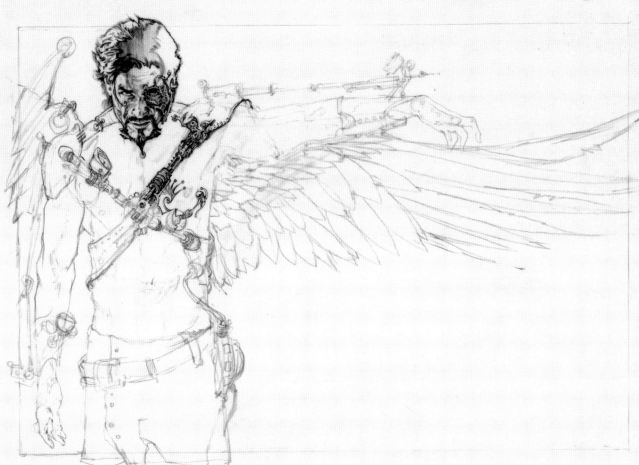

▲ **Step Four** In this step, we'll work on the chest gear. Remember that steampunk characters have antique qualities while serving a futuristic purpose. To capture that feel, vary the sizes and shapes, keeping the shapes quite simple. Notice the way the chest gear is made up of mostly circles, spheres, cylinders, and rectangles.

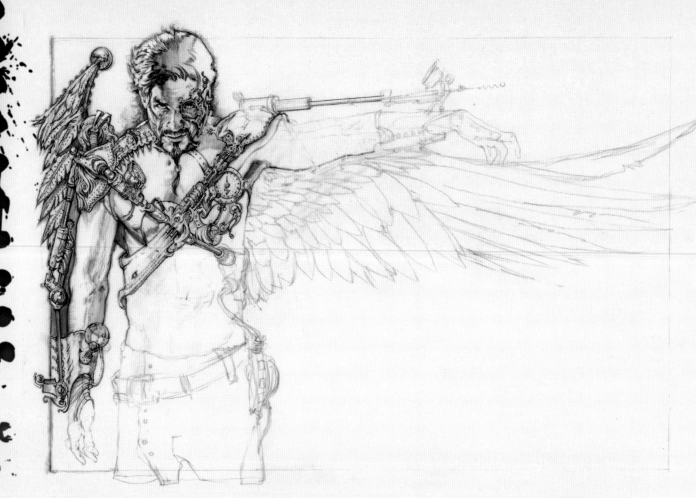

▲ **Step Five** Now, begin designing the right wing and work downward. The wing is mostly a matter of indication. The feathers are metallic, so they're drawn in with hard straight edges. The midsections of the feathers are lined with dots as their bolts.

▶ **Step Six** Let's make the torso strap out of leather. Then, add some wires and gauges. It's a mixture of old and new, after all.

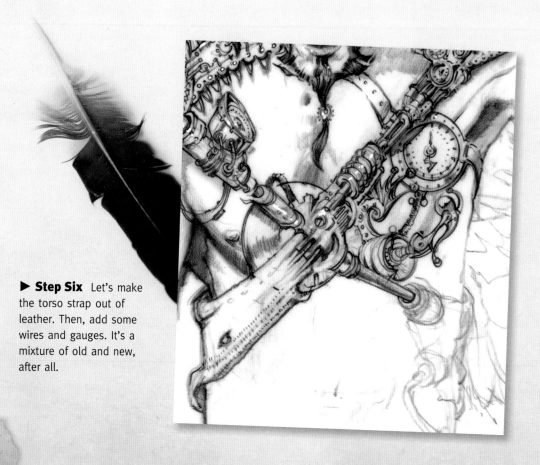

▶ **Step Seven** Next, finish the right arm. To keep the mechanism believable, it's important to create pivotal joints for the elbow and shoulder. The wrist also needs room to move.

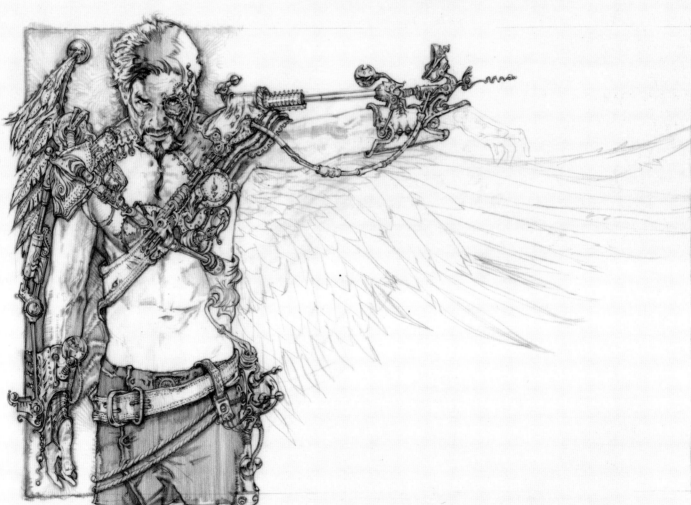

▲ **Step Eight** With all that's going on with the gear, the drawing could easily start to look stiff and robotic. To avoid that, use both organic, curvy shapes and plenty of straight edges in the design. It also helps to mix in soft materials like the leather on the angel's shoulders, chest straps, and belt, and the fabric of his pants.

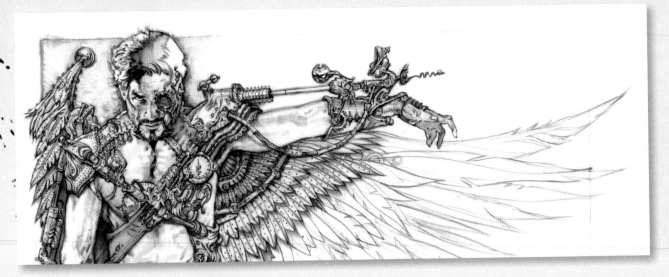

▲ **Step Nine** It's evident from his physique that this is one tough angel. Still, he should look slightly eccentric. This is expressed through the uncommon gear he wears, as well as the less obvious nuances, like the pose of his left hand and the clip that tames his goatee.

▶ **Step Ten** Keeping the torso simple in rendering and value allows it to act as a clean canvas for the wings and its mechanisms. First, darken the values behind the angel's body to create more contrast between him and the background. Next, add little strokes going in different directions in the negative space between his right arm and body. This indicates the right wing's complexities, evident even in shadow. For the background, design swirling strokes in a light value to look like energy radiating off of him.

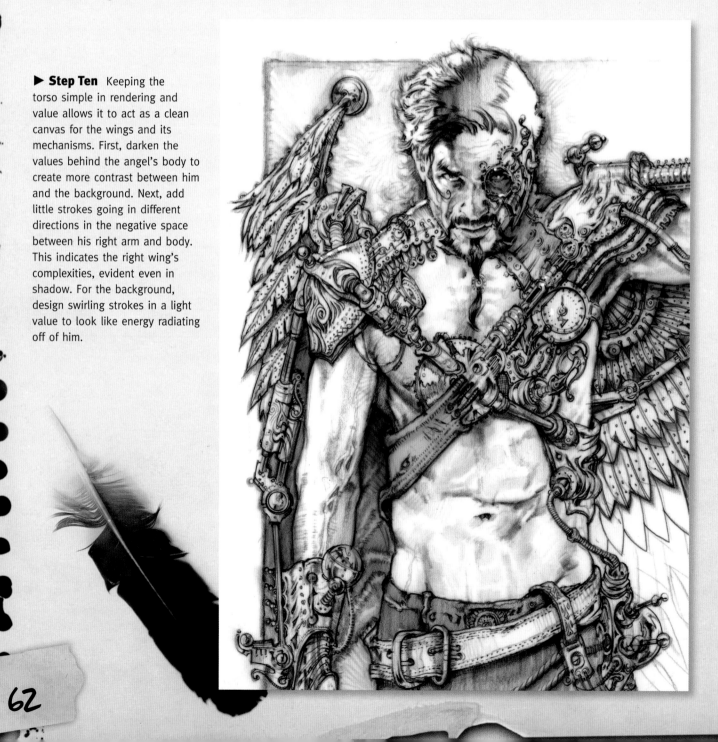

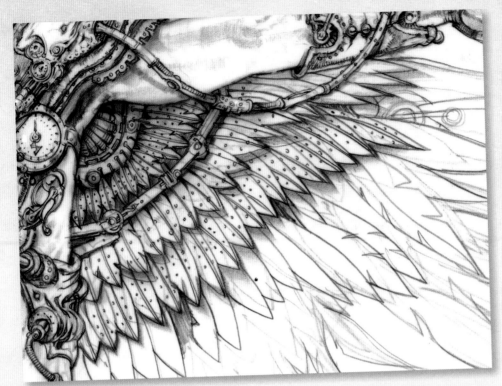

◄ Step Eleven In the splayed wing, design a pattern of metallic feathers that increase in size as they radiate outward. The feathers should get lighter in value so that they avoid looking bottom-heavy. Adding spokes and gears in between each tier make the wing look both functional and attractive.

▼ Step Twelve At this stage, you have the option of scanning the drawing into Photoshop® to take it to the next level.

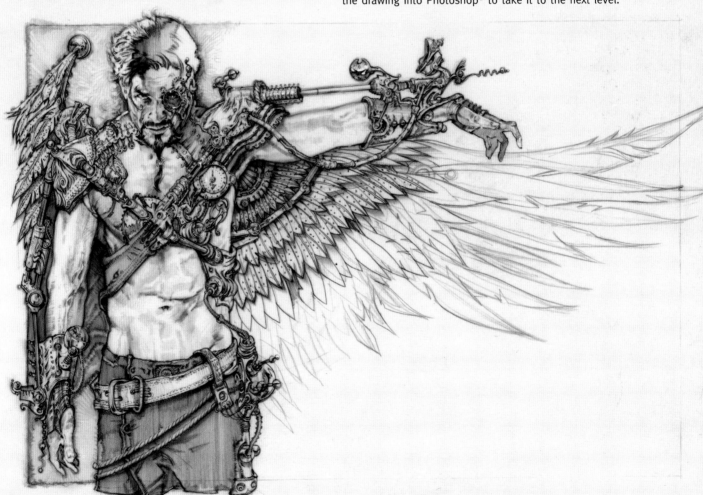

▶ **Step Thirteen** This is how my office is set up when I'm working digitally. I have three 30-inch monitors and one Wacom Centiqu that I can draw directly on. I only used the three screens for this project. As you can see, the screen on the far left displayed the original scanned artwork, so I could always refer to it. The other two allowed me to zoom in and work further on the drawing.

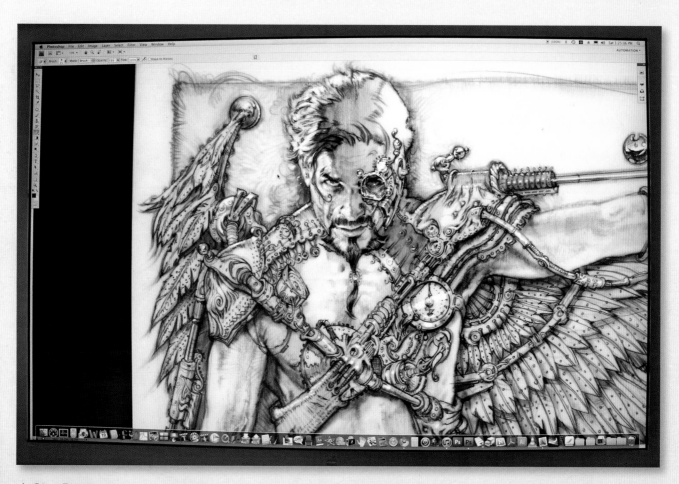

▲ **Step Fourteen** If you have it, Photoshop is ideal for finishing this drawing. It's quick and accessible—invaluable traits when time is of the essence. I mainly use the eraser and the burn tool for highlights and for darkening some shadow areas.

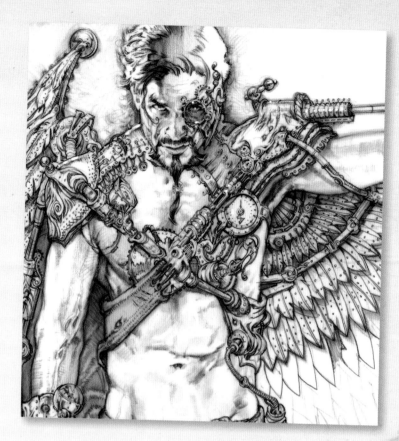

▶ **Step Fifteen** These areas are good examples of where the eraser tool was used to create highlights. First, select the eraser tool, and change the diameter of the brush to a setting appropriate for the size of the area you're working on. Keep the hardness at zero to create the soft, metallic highlights. The opacity can vary between 30% and 90%. The fabrics get lower opacity, because they're less reflective. The highly reflective material gets a higher opacity.

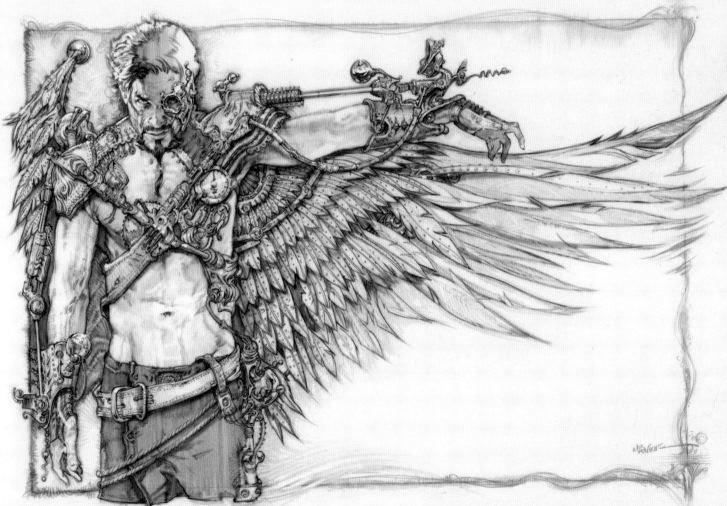

▲ **Step Sixteen** In this last step, use the burn tool to darken the areas that should recede, like under the arm and behind the torso. After selecting the burn tool, select "midtones" for the range. The exposure should remain at around 50% so that you can control the value.

Chapter 3:
Painting

Painting materials

Painting is generally more difficult than drawing because, in addition to strokes and values, you must also consider color and its many aspects—saturation, hue, paint mixing, color schemes, etc. By following the projects in this chapter step by step, hopefully you will get ideas for how to approach color and develop your paintings. The focus of this chapter will be on the painting aspect; however, as in Chapter 2, you will have the option of finishing the paintings with a few digital tweaks.

Toothbrush

Acrylic Paints

Paint Palette

Materials Checklist

To complete all the painting projects in this book, you'll need to purchase the materials below. Note that the exact materials needed for each project are listed at the start of each project:

- Acrylic paints: Alizarin crimson, black, burnt umber, cadmium red, light blue violet, titanium white, yellow ochre
- Black and white gouache
- Colored pencils: black, blush pink, terracotta, Tuscan red, white, and a good assortment of other colors
- Multimedia vellum paper
- Bright white polypropylene paper
- Masonite board (11" x 17")
- White gesso
- Matte medium
- Workable spray fixative
- Palette box
- A variety of synthetic brushes ranging from #00 to #6 (very small to medium)
- Large house-painting brush
- Paper towels
- Old toothbrush
- Window cleaner
- Bowl of water
- Scratch paper
- Eraser
- Pencil sharpener
- Airbrush
- Access to scanner or color copier

Eraser

Acrylic Paint

Acrylic paint is fast-drying paint containing pigment suspended in an acrylic polymer emulsion. Acrylic paints can be diluted with water, but become water-resistant when dry. Depending on how much the paint is diluted (with water) or modified with acrylic gels, media, or pastes, the finished acrylic painting can resemble a watercolor or an oil painting, or have its own unique characteristics not attainable with other media. You can apply acrylic in thin, diluted layers, or apply it in thick, impasto strokes.

Finding Inspiration While learning how to draw and paint angels, it's a good idea to surround yourself with plenty of visual stimulation. An entire corner of my studio is devoted to reference books and props.

Paintbrushes

When using acrylics, we recommend synthetic hair paintbrushes. For the projects in this book, you'll want a variety of sizes, from size 00 (very small) to size 6 (medium). Also consider gathering a variety of bristle shapes. Round brushes have bristles that taper to a point, allowing for a range of stroke sizes. Flat brushes have bristles that are pinched into a squared tip. The flat edge produces thick, uniform lines. In addition to these acrylic brushes, you'll also want a house painting brush—a large paintbrush with coarse bristles. These brushes are perfect for quickly covering the canvas with large washes of color. If you own an airbrush, use this when recommended in the projects, as it produces incredibly soft, realistic gradations that are more difficult to achieve with paintbrushes.

Painting Surfaces

You can use acrylic paint on practically any surface, as long as it's not greasy or waxy. As a result, you have a lot of flexibility with your painting surfaces. However, it's best to paint on either canvas or illustration board coated with a white gesso (a coating used to create an ideal painting surface). Remember that the brighter (or whiter) your painting surface, the more luminous your colors will turn out!

Colored Pencils

Colored pencils aren't just for drawing; they are great tools for adding details to a painting. Working directly over acrylic paint, you can add highlights, intensify shadows, create strands of hair, and more. It's important to purchase the best colored pencils you can afford; higher quality pencils are softer and have more pigment, giving you smoother, easier coverage.

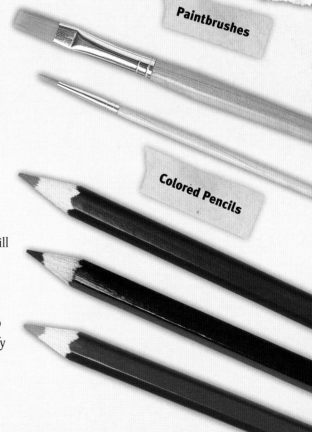

Paintbrushes

Colored Pencils

69

fallen angel portrait

His descent into hell has left him battered and deadened to the core. So what's with the penetrating gaze and sexy smirk that make this fallen angel so undeniably attractive? That's just the way it goes with these demonic types. Like Satan, himself, our cover boy has the means to beguile his way into the purest of hearts, and make their owners forget about being bad.

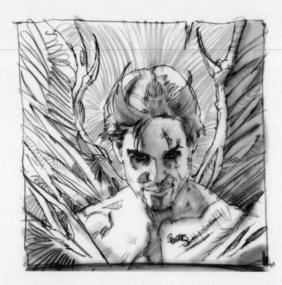

▶ **Step One** This project will ultimately be a tightly cropped portrait of the menacing, yet attractive, fallen angel on the cover. The portrait is based on a headshot of a terrific male model wearing a slightly aggressive expression. Let's start with a quick thumbnail and a terracotta colored pencil for the drawing.

Materials
- Acrylic pains: alizarin crimson, burnt umber, cadmium red, light blue violet, titanium white, yellow ochre
- Palette box
- Matte medium
- A variety of small acrylic paintbrushes
- Large, old paintbrush
- Masonite board (11" x 17")
- Vellum paper
- Colored pencils: black, blush pink, terracotta, Tuscan red, white, and a good assortment of other colors
- Electric pencil sharpener
- White gesso
- Eraser
- Airbrush
- Access to a scanner or color copier

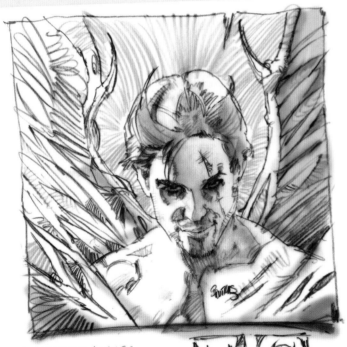

◀ **Step Two** Notice how I played around with a few light and shadow ideas but chose a strong, single source of light from the left. Making notes to remember elements you may want in the illustration is also useful. For the shadows and hair, hit the drawing with a quick spray of the airbrush. A mixture of burnt umber and water works well.

#1 TEXTURE / WINGS
#2 DEEP SHADOWS
#3 SILHOUETTE WINGS?
#4 ORGANIC SHAPES
#5 BG CLEAN
#6 DEPTH
#7 COOL SKIN TONES
#8 START WARM
#9 HAIR INDICATES HORNS
(SUBTLE SECOND READ.)

LIGHT

WINGS ATTACHED TO-

DARK TO LIGHT: STRONG CORE SHADOWS

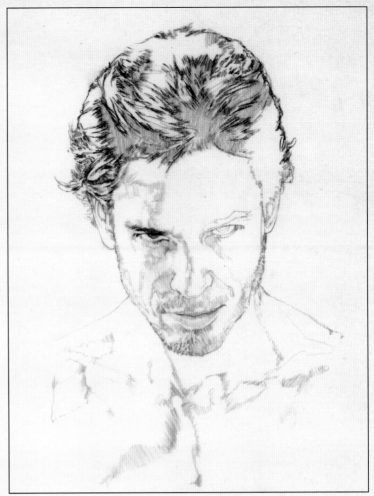

▶ Step Three After deciding on the composition, begin drawing. With the photograph of the model taped to my table, I started the drawing using the terracotta pencil over a sheet of vellum. Using a colored pencil in a warm tone prevents it from clashing with the colors we'll layer on when the drawing is finished. It helps to keep the pencil extremely sharp. Also, having several sheets of paper underneath gives the pencil a little "bounce."

◄ Step Four You can see that even the shapes within the hair are thoughtfully designed. There are also some large light and dark shapes, so that the detail of every strand is less important. Use the side of the pencil to create the core shadows in a lighter value. Then, carefully shade in the darks with consistent strokes. This immediately creates an impression of depth.

▶ Step Five Now, lightly map out the light and shadow patterns with pencil strokes that follow the anatomy. For some areas, such as the beard, try switching to a Tuscan red pencil. The result is a slightly darker value. It also helps differentiate the facial hair from the rest of the face.

▶ Step Six In this step, we'll continue to fill in the remaining shadow areas. It's important to keep the hair and the eyes the darkest parts of the picture. The model I used has extremely symmetrical features that required roughening up. After all, this fallen angel has been around for some time. I tweaked the bridge of his nose by curving the core shadow that runs along the top. Raising the right corner of his mouth a bit gave him a smirk and added some creases around his eyes and mouth.

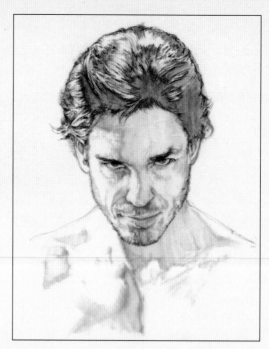

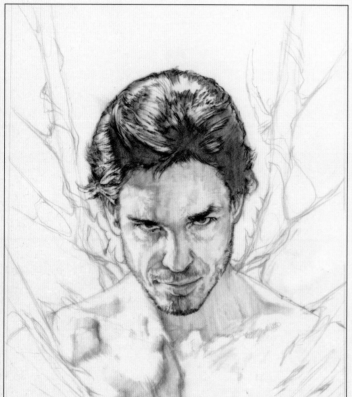

◀ Step Seven Now for the wings. Because this is a close-up, there isn't a lot of room. But we want to give the impression that his wings are magnificent yet intimidating. First, draw the wings directly off the page and use them to frame his head. Keep the lines light and whimsical. Playing around with the size of the shapes helps preserve the organic nature of the wings.

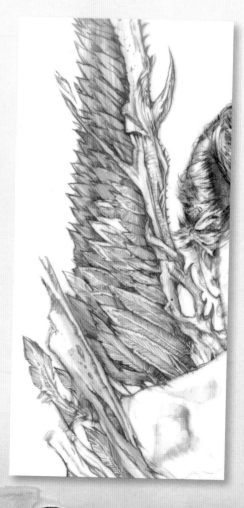

▶ Step Eight When creating an element like wings, it's wise to gather plenty of reference material for inspiration. Photos of birds in flight make the anatomy of their wings clearer. Then, you can add your own twist. This dark angel has wings reminiscent of a prehistoric bird of prey, with exposed cartilage and sharp, talon-like edges. Start off with an overall mid-value to keep the wings in the background. Then, quickly indicate the feathers, increasing the size as they come to the forefront. To give the wings a slightly battered appearance, separate and define a few of the feathers. I left a few gaps in between, as if the feathers never grew back after a particularly nasty battle.

▶ **Step Nine** Let's experiment with the eyes before going any further. First, make a copy of the drawing onto regular copy paper. Now, take the airbrush, and mix a little burnt umber, alizarin crimson, and water. Then, darken the eyes until they resemble two glistening black wells.

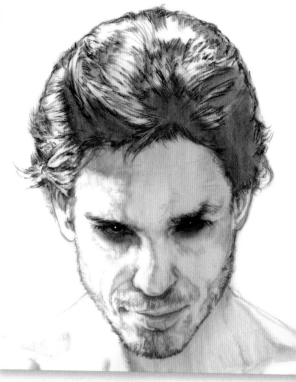

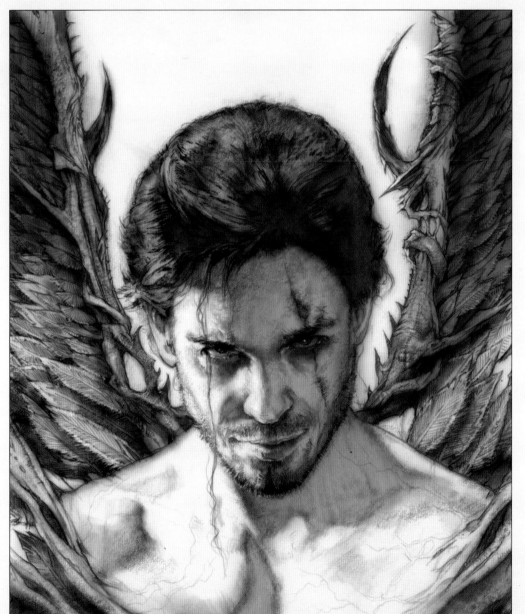

◀ **Step Ten** Back to the original drawing, where we'll incorporate the eyes. Making them a little less dark will show more detail. From this point, use the Tuscan red pencil to darken around the eye sockets. A couple loose strands of hair around the face and a battle scar down the left side add intrigue.

73

▶ Step Eleven
Now, let's finish the wings, adding details only to the feathers in the forefront. Notice the way parts of the wings are brought to the front of his torso, as if they're engulfing him. This is another way to frame the character and create an attractive border for the illustration. By drawing outside the box, the composition avoids being stiff and remains exciting.

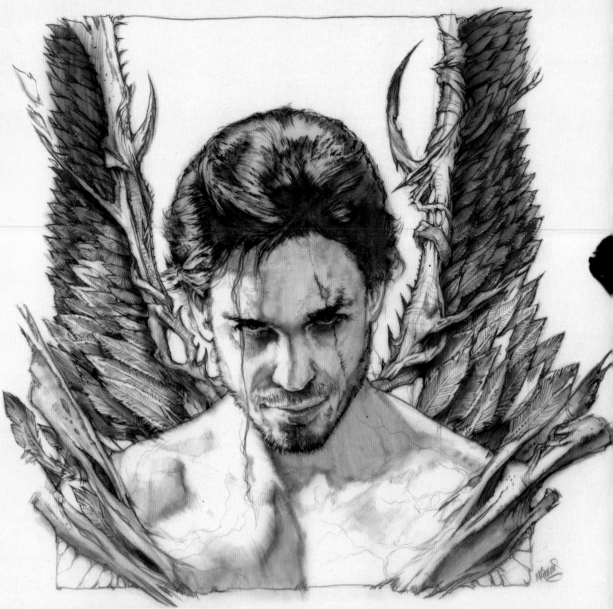

▶ Step Twelve It's time to paint. Place the drawing on a scanner and print out a copy on standard copy paper. I've made mine 11" x 10", but you can make it any size you wish. Next, mount the copy onto a Masonite board by brushing it with a mixture of 50% matte medium and 50% water. This seals the copy and will make it easy to paint over it once it's thoroughly dry.

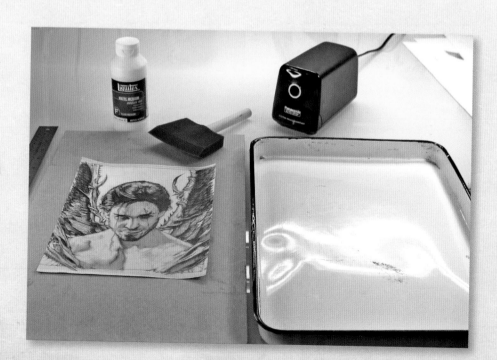

74

▶ **Step Thirteen** In this step, we'll lay in all the dark values. In doing this, you can see all the large graphic shapes and keep the values intact. Take the airbrush and fill it with burnt umber. Then, lightly spray the shadow and dark areas, including the hair, wings, and majority of the face.

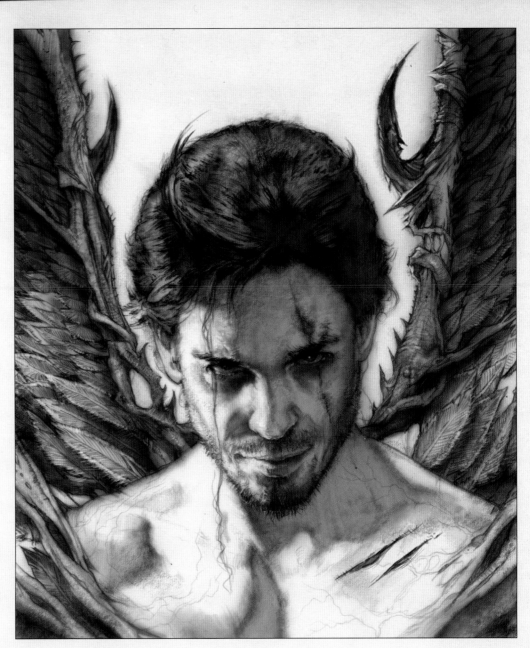

Step Fourteen Now, using the burnt umber pencil, draw in a couple flesh wounds under the angel's left clavicle. The shape can be whatever you desire. I wanted mine to look like knife or claw lacerations, so I drew them slender and sharp. Next, unevenly outline the perimeter. Then, fill it in with a lighter value.

Step Fifteen Here, we'll continue to use the burnt umber pencil to bring up the hair to form two subtle points. Now our angel's hairstyle mimics popular depictions of the devil. For effect, add horn-like protrusions to the wings behind him.

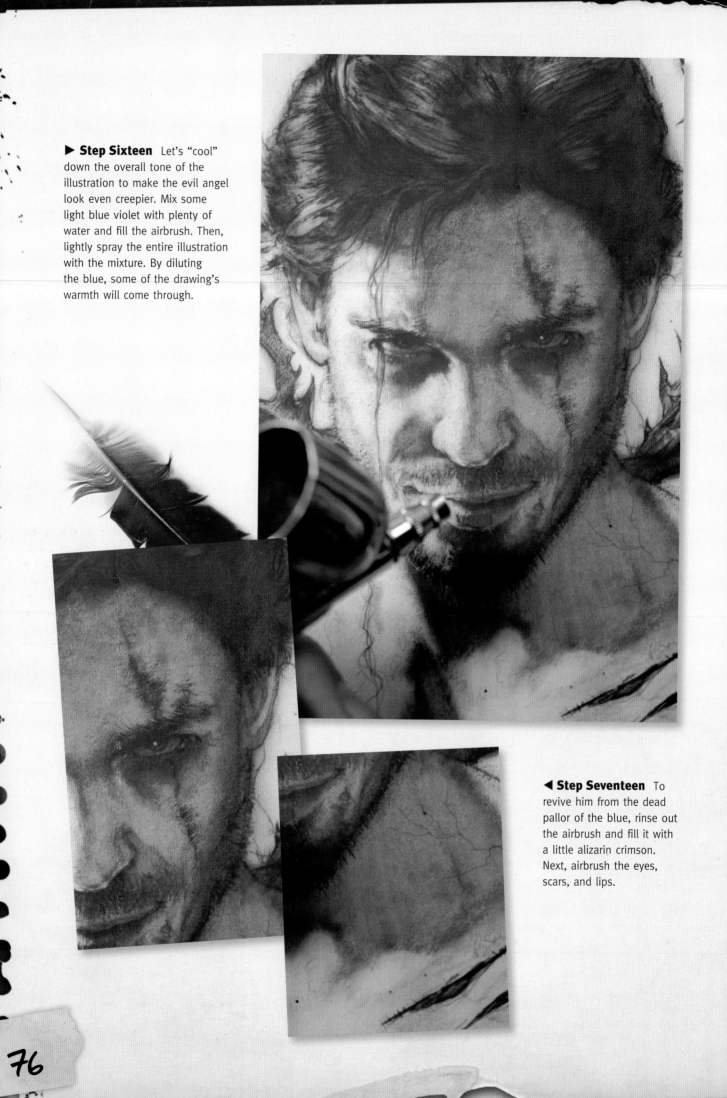

▶ **Step Sixteen** Let's "cool" down the overall tone of the illustration to make the evil angel look even creepier. Mix some light blue violet with plenty of water and fill the airbrush. Then, lightly spray the entire illustration with the mixture. By diluting the blue, some of the drawing's warmth will come through.

◀ **Step Seventeen** To revive him from the dead pallor of the blue, rinse out the airbrush and fill it with a little alizarin crimson. Next, airbrush the eyes, scars, and lips.

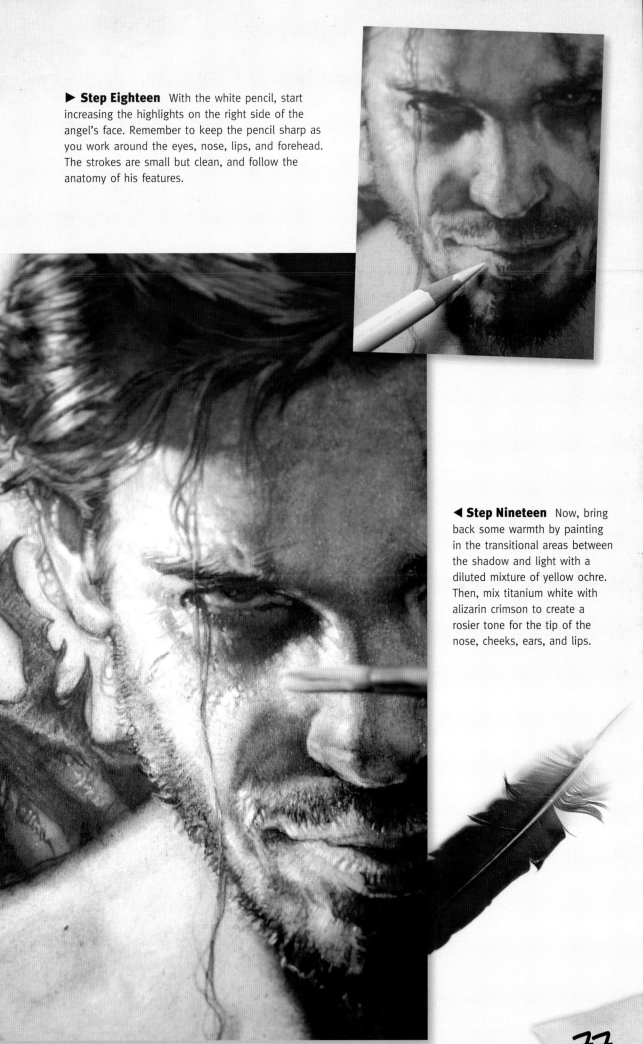

▶ **Step Eighteen** With the white pencil, start increasing the highlights on the right side of the angel's face. Remember to keep the pencil sharp as you work around the eyes, nose, lips, and forehead. The strokes are small but clean, and follow the anatomy of his features.

◀ **Step Nineteen** Now, bring back some warmth by painting in the transitional areas between the shadow and light with a diluted mixture of yellow ochre. Then, mix titanium white with alizarin crimson to create a rosier tone for the tip of the nose, cheeks, ears, and lips.

▶ **Step Twenty** To make his eyes and scar warmer and more saturated than the rest of his face, first mix a little alizarian crimson, burnt umber, and water with a small brush. Next, paint these features until the desired value is achieved. Use a dab of cadmium red for the rim of the right eye, because the light is hitting it.

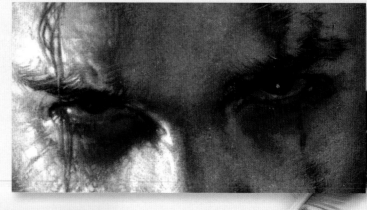

▶ **Step Twenty-One** Follow the same steps with the shoulders and the chest. Most of the subtle changes of warm and cool colors come from the layers of airbrush over the drawing. For the pectoral muscles and shoulders, use a mixture of alizarian crimson and yellow ochre with a lot of water. Light strokes of blush pink pencil over the same areas adds texture.

▶ **Step Twenty-Two** To create the highlights, use a small brush and a little bit of water to white gesso. The gesso picks up the color underneath, creating a natural transparency. Notice how I kept the brush strokes chiseled. This helps uphold the integrity of the drawing underneath, as well as the masculine qualities of this dark, brooding angel.

▶ **Step Twenty-Three** The blood stains were done very quickly and easily. Use the brush to mix water with a bit of alizarin crimson. Then, dab splotches of paint around the gashes. This lends a dash of spontaneity and energy to the piece.

▼ **Step Twenty-Four** The drawing in this illustration is the technique that requires the most time. When your drawing and values are on point, it's only a matter of layering large masses of color and a bit of rendering. That's why the wings appear much more detailed than they really are. I allowed the drawing to come through the layers of warm and cool airbrushing I applied over them. Next, use the white pencil to add highlights along the edges of the larger feathers in front.

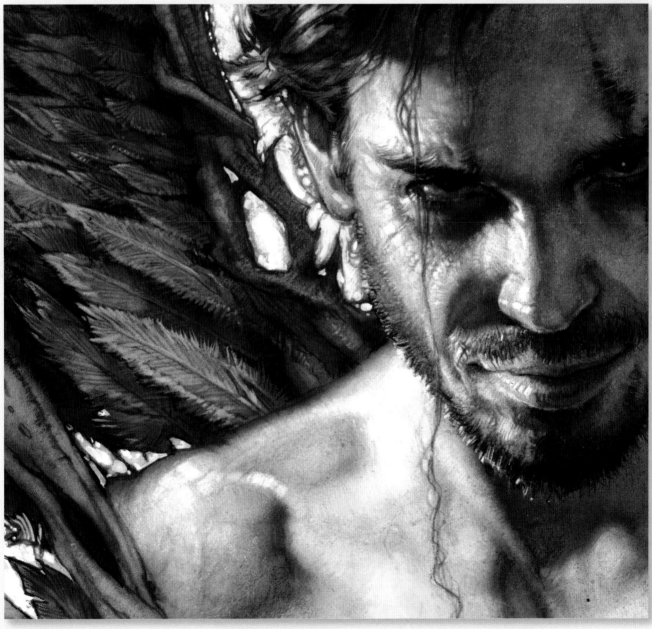

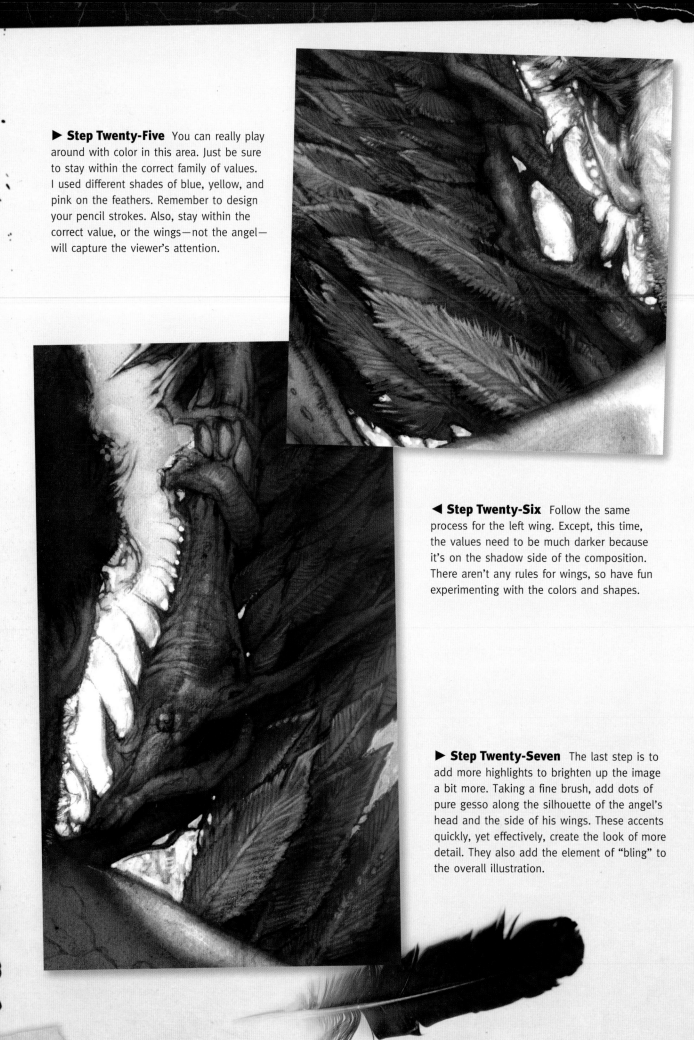

▶ **Step Twenty-Five** You can really play around with color in this area. Just be sure to stay within the correct family of values. I used different shades of blue, yellow, and pink on the feathers. Remember to design your pencil strokes. Also, stay within the correct value, or the wings—not the angel—will capture the viewer's attention.

◀ **Step Twenty-Six** Follow the same process for the left wing. Except, this time, the values need to be much darker because it's on the shadow side of the composition. There aren't any rules for wings, so have fun experimenting with the colors and shapes.

▶ **Step Twenty-Seven** The last step is to add more highlights to brighten up the image a bit more. Taking a fine brush, add dots of pure gesso along the silhouette of the angel's head and the side of his wings. These accents quickly, yet effectively, create the look of more detail. They also add the element of "bling" to the overall illustration.

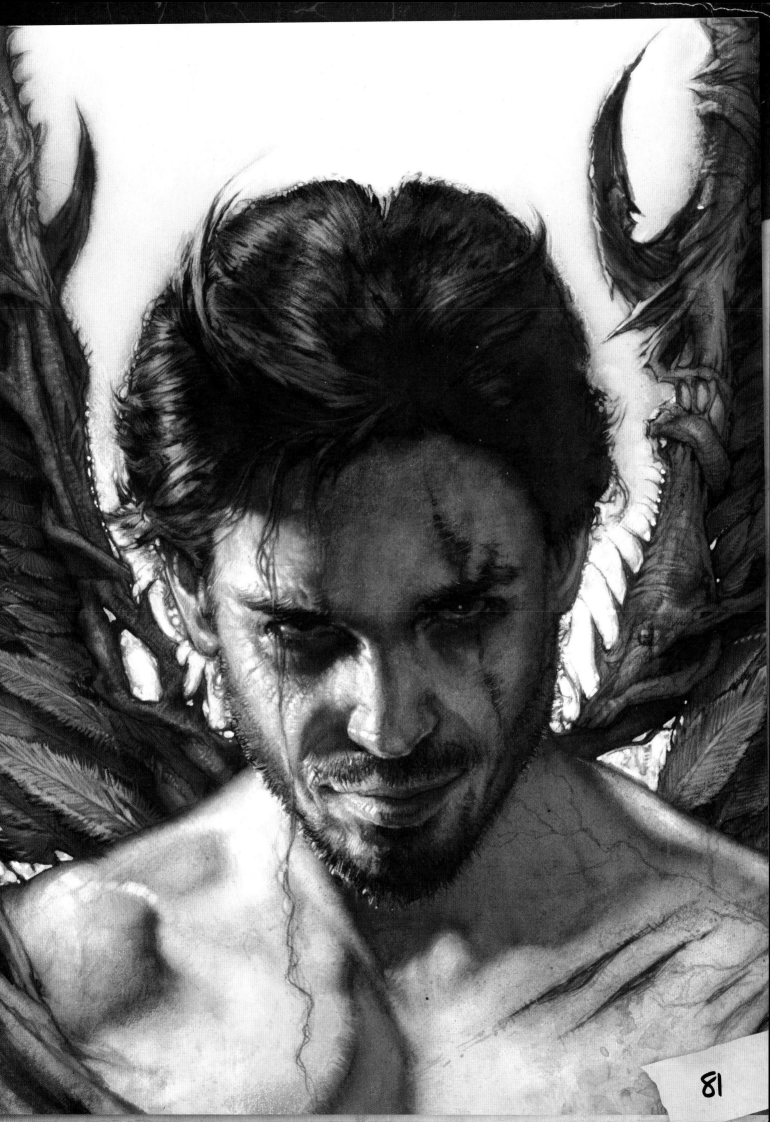

angel on the edge

His arms etched with the markings of his tribe, our warrior angel firmly grips his ancient sword as he peers gravely down into the world below. But does his gaze fall upon Earth or hell? Or are they one in the same? Lighting creates the drama here. And in this project, you'll learn how to create an under-lit figure with indeterminable intent.

◀ **Step One** Here's a look at the materials and setup I used for this next painting. It's quite simple, but as you'll find out, the polypropylene paper combined with the black gouache is very versatile and will yield amazing results.

▶ **Step Two** I wanted to do a watercolor painting for this project, but was looking for a new type of canvas I hadn't used before. The art store clerk recommended this polypropylene paper to me, and I was pleasantly surprised after experimenting with it. Before starting the painting, I tested the paper by creating some fun little creatures. The paper is extremely durable and is non-absorbent, which was conducive to this pick-out technique.

▶ Step Three Start off with a preliminary drawing of the angel before beginning to paint. My idea was to illustrate a warrior angel crouching on a precipice, looking down. Notice the way he's under-lit. I referenced a photo from a model shoot for the body positioning. However, I also relied upon a bit of figure invention. It's important to be extremely familiar with the figure(s) you're inventing. Nothing will ruin a potentially gorgeous painting quicker than an inaccurate drawing.

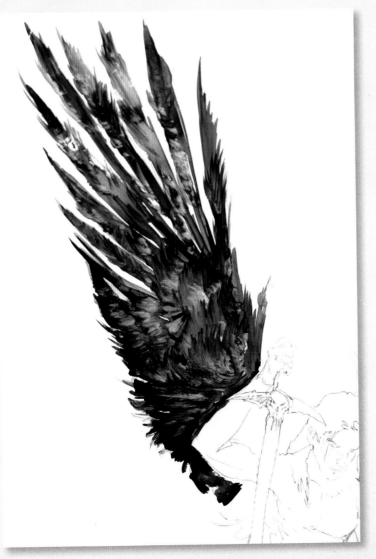

◀ Step Four Now, with some black gouache on a sheet of palette paper and a small bowl of water, it's time to paint. Use a small brush and straight gouache to lay in the wings by painting in shapes. Because the paper is extremely smooth and non-absorbent, it's easy to push and pull the paint and create a variety of brush strokes.

▶ Step Five In this step, soften the crisp edges and create a glow. Load the airbrush with a bit of black gouache and water until you achieve a medium gray color. Then, keeping the air pressure at around 10 psi, lightly spray all around the wing.

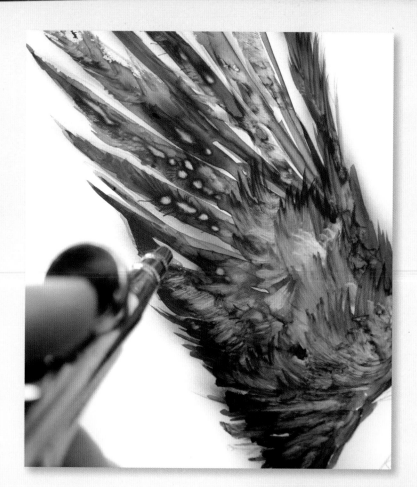

▼ Step Six Quickly lay in the other wing in the same manner, using only the gouache. Don't worry about the saturation of the black paint or making the form of the wing precise. On this paper, the paint will remain very malleable, and you can manipulate it later.

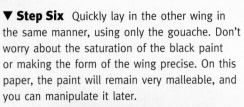

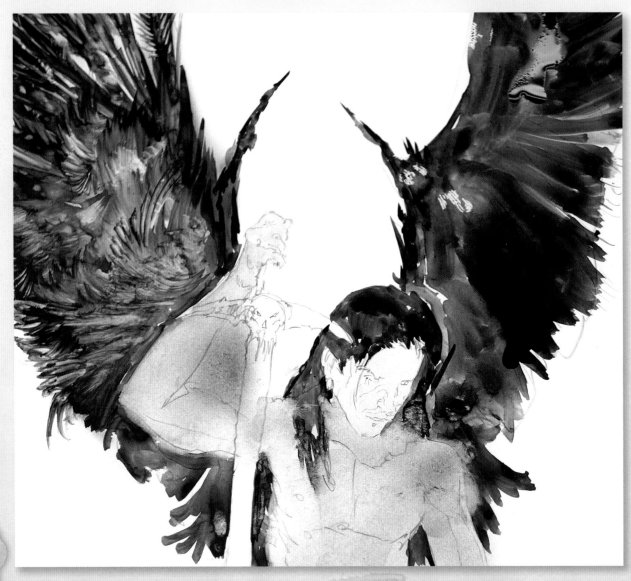

▶ **Step Seven** Using the airbrush, lay in a medium value for the body. Don't be concerned about the overspray. It will add to the glowing effect. I decided to use the airbrush instead of the paintbrush because I wanted the texture of the wings to be different from the body.

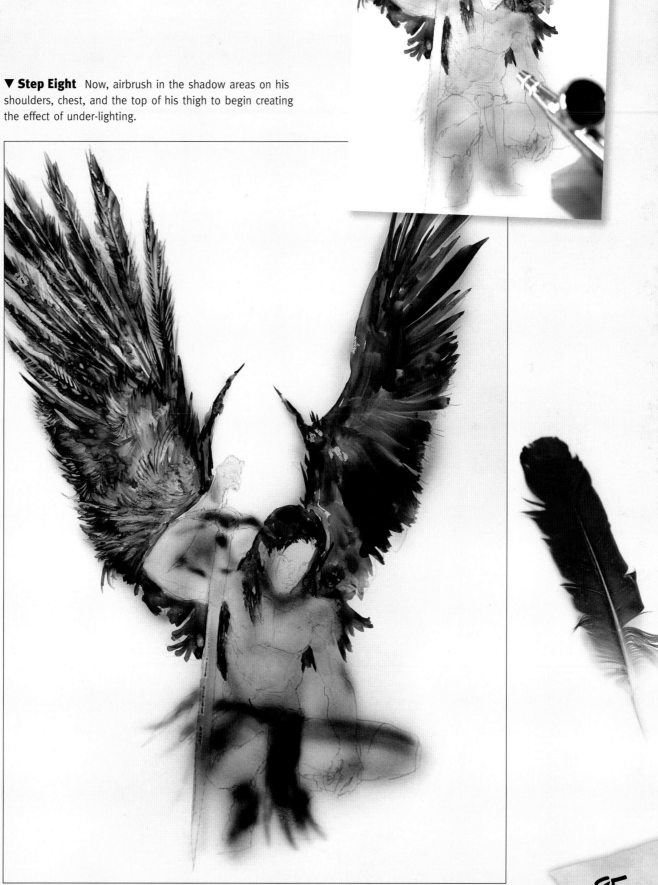

▼ **Step Eight** Now, airbrush in the shadow areas on his shoulders, chest, and the top of his thigh to begin creating the effect of under-lighting.

▶ Step Nine On to the pick-out technique. Notice the way I changed the look of the wings, splaying them outward, as if wings of a proud eagle. The beauty of this paper is that is allows you to remove undesired areas by simply going over them with a wet brush. Use the same technique for the body. First, wipe the brush. Then, wet it. Now, begin to "carve" out his torso. I did this to the underside of his muscles to emphasize the under-lighting.

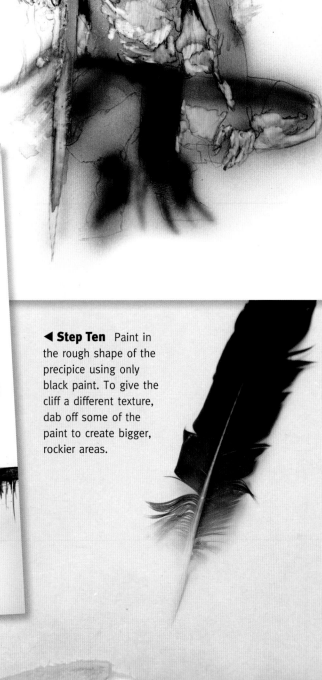

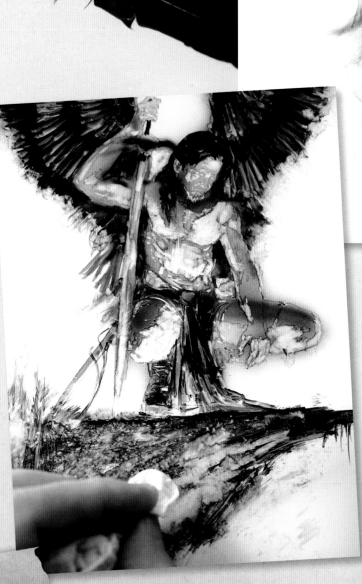

◄ Step Ten Paint in the rough shape of the precipice using only black paint. To give the cliff a different texture, dab off some of the paint to create bigger, rockier areas.

▶ Step Eleven It's fun to play with the crag, because it offers a variety of textures to experiment with, and yet, it isn't necessary to be accurate. For this look, simply stipple with the brush for the pebbly area. Then, pull the paint up and down with a wet brush for plant life. Use the paper towel again for the larger rocks.

▼ Step Twelve Now, with a super-fine, damp brush, chisel the angel's face by removing the airbrushed paint. I followed the anatomy of the face in the photo reference. The only difference was that I had to paint it as if under-lit. If you have trouble imagining different lighting circumstances, try getting a friend to pose for you in the same conditions. It's a great way to get a basic feel for lighting.

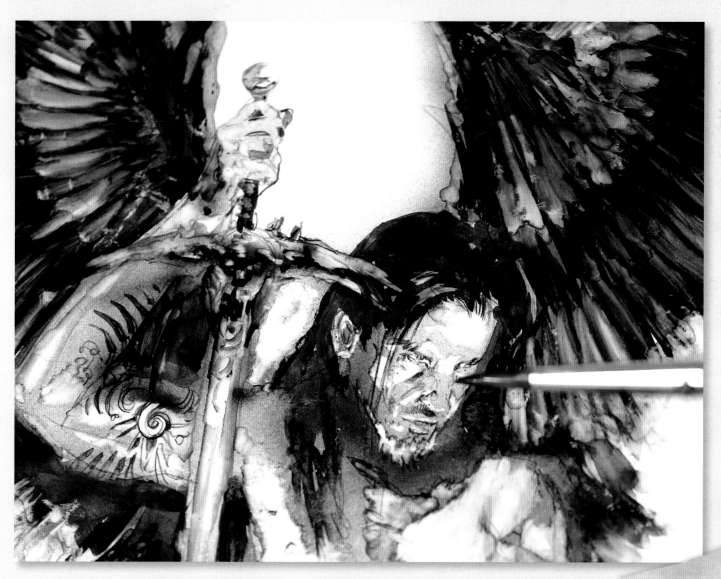

87

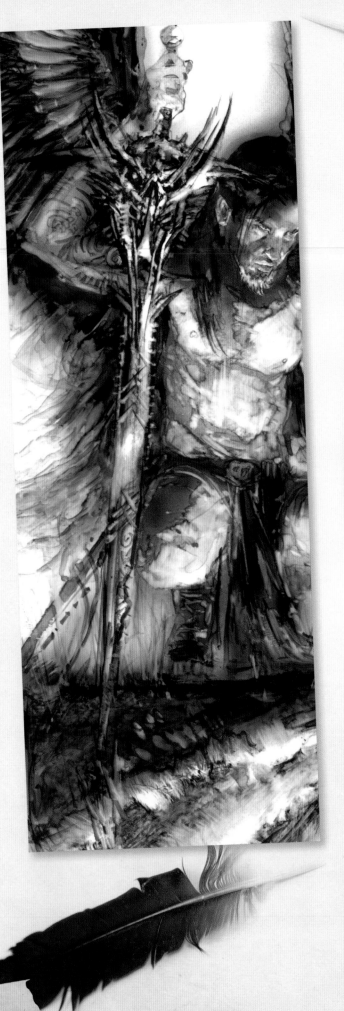

◀ **Step Thirteen** Use the fine-tipped brush to finish designing the sword. I wanted it to look worthy of an angel, forged by the hands of some unearthly blacksmith. To make the design look intricate, keep the shapes small and geometrical. I also wanted the highlights to pop as only metallic highlights can. To achieve this, carefully paint dark accent shapes. Then, wet a clean brush and remove the paint in the areas next to these accents where you want highlights.

▲ **Step Fourteen** Let's move on to the tattoos on the angel's arm. Begin by drawing them in with a brush, just as you would if you were using a pencil. The most important thing about inventing tattoos is that they must follow the form of the anatomy they're on and reflect the light accordingly.

▶ **Step Fifteen** In this final step, we'll create more stringy, overgrown plants on the cliffs. We'll also add some mysterious, feathery down coming out of the angel's wings. This infuses a bit of whimsy into the otherwise stoic mood of the painting. Lastly, brighten a few more highlights by removing the paint in those areas to reveal the original white paper. It's simple to make revisions, even after the paint dries. Remember, the paper is non-absorbent, so all you need is a brush and some water. If you want to seal it, however, you'll need spray fixative.

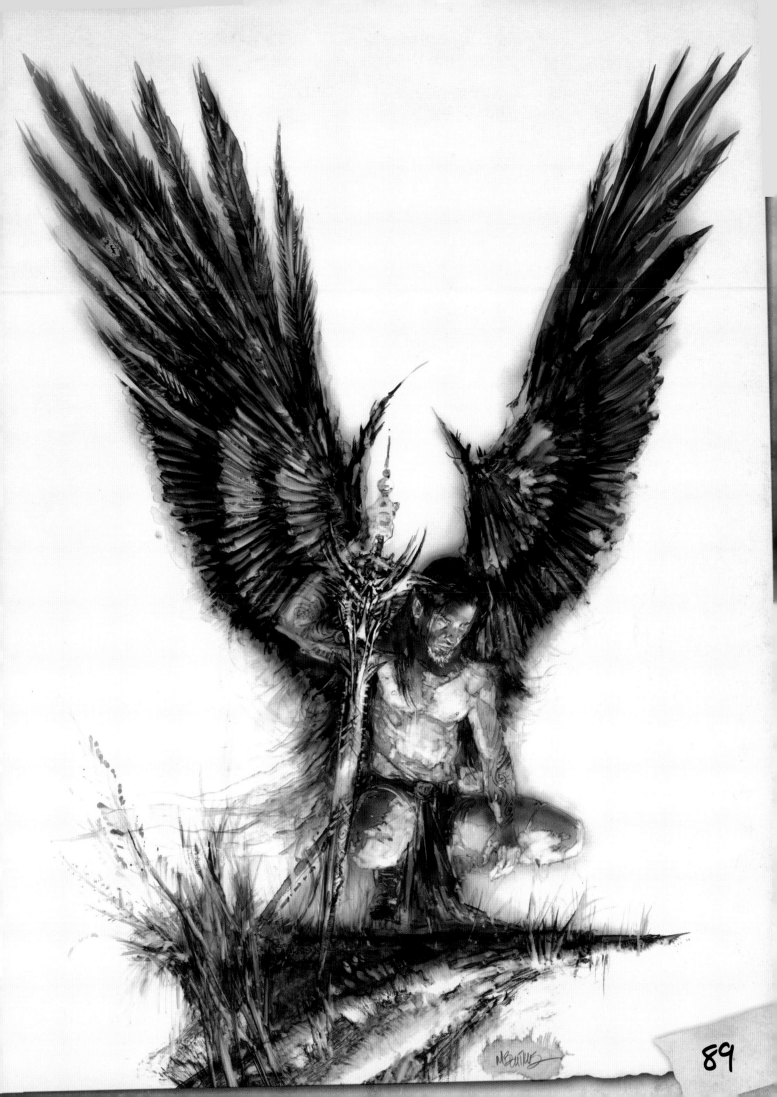

angels up Close

"Millions of spiritual creatures walk the earth unseen,
both when we wake and when we sleep."
—John Milton in *Paradise Lost*, IV

Angel Encounters Around the World

There are books and Web sites dedicated to angel sightings, talk shows dedicated to human encounters with "mysterious strangers," and even purported evidence of angels on YouTube. Author and lecturer Joan Wester Anderson became a publishing sensation in 1992 with her book *Where Angels Walk, True Stories of Heavenly Visitors*, which remained on the *New York Times* best-seller list for more than a year and has been translated into 14 languages. After becoming a fixture on morning television talk shows and in documentaries on angels, Anderson answered the demands of her adoring fans by releasing *Where Miracles Happen, True Stories of Heavenly Encounters* and *An Angel to Watch Over Me, True Stories of Children's Encounters with Angels*, two years later. Needless to say, a great deal of mortals are captivated by angel encounters, which at this point in time are so frequent that it's difficult to argue with the possibility that angels walk the earth.

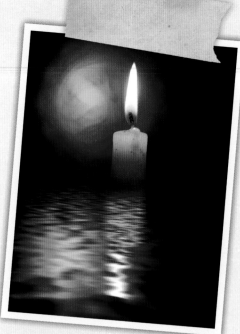

In one contemporary account submitted to a Web site devoted to interactions with angels, the writer recounts a road trip with her mother and grandmother taken when she was a young child. She'd strayed from her family members during a hike, and when she glanced back to answer their call, she realized the dire situation they were in. In an attempt to prevent her grandmother from plummeting over the edge of a cliff, her mother had grasped her mother's arm, which sent them both edging over the side. "Out of nowhere" two men dressed in climbing gear who barely spoke English appeared just in time to grab the mother and lift the grandmother from harm's way as if she were weightless. When everyone came to their senses, the good Samaritans had disappeared.

An alleged angel caught on security camera was the cause of much local speculation in Charlotte, North Carolina, only days before Christmas in 2008. Colleen Banton, whose daughter had been hospitalized with chronic health problems, had decided to take her daughter off life support. As she sat in the waiting room, Colleen's sister insisted she look up at the security camera. When Colleen did, she saw an illuminated figure walking across the screen. Miraculously, her daughter began improving after being taken off life support, and returned home following a three-month hospital stay.

Of course, angel visitations are hardly a modern phenomenon. Mankind has had encounters with angelic beings for as long as man has existed. Remember Zoroaster, who envisioned the angel Vohu Mana, a being nine times the size of man. In the Bible, Jacob wrestles with an angel until daybreak. The angel dislocates Jacob's hip in the process, but ultimately blesses him because he remained strong in the face of God. English poet William Blake also confessed to seeing angels in trees when he was 10 years old, a momentous occurrence that influenced his writing and many of his paintings.

That's why this book is so useful. If you ever happen upon an angel, be it helpful, quarrelsome, or dark in spirit, you'll be well versed in the appropriate method to capture its likeness for people to refer to for centuries to come.

How Angels Communicate

It's difficult to ascertain from accounts rooted in folklore and various religious scripture whether angels who reveal themselves to humans actually speak to them in some form of intelligible speech or transfer thoughts from their minds to mortal minds. In his book *The Angels and Us,* Mortimer J. Adler said that if you posed the question to theologians, they'd say that angels influence and communicate with their human counterparts indirectly.

According to Adler, the methods angels use to communicate are similar to those used in teaching, so consider the way one adult teaches another to change a tire. There isn't any implanting of knowledge going on—it just isn't possible. It's primarily about showing, and perhaps a little telling. Theologians don't believe it's possible for angels to fill human minds with ideas either. Instead, in the same manner that teaching is based on examples—vocabulary, pictures, motions—angels' impact on man relies upon their ability to affect the sense and imagination, which in turn influences the way the human intellect operates.

In one incredible account, an angel certainly affected the senses—by attack of all things. Teresa of Avila (1515-1582), a favorite saint among Catholics, claimed that although she hadn't witnessed an angel previously, one appeared to her in bodily form—an exquisite body of flames, that is. Without identifying himself, he repeatedly plunged the blazing tip of his golden spear into her heart. The sensation, Teresa recounted, was pleasant rather than painful. As a result of the unbelievable encounter, Teresa swore her soul would only want God from then on. Gianlorenzo Bernini immortalized the experience with his well known sculpture, *The Ecstasy of St. Teresa* (1647-1652).

At age 13, Joan of Arc, patron saint of France, began hearing the voice of God, which convinced her that she'd been called upon to drive the English out of France. Over time, she also heard the voices of Catherine of Alexandria, Margaret of Antioch, and the archangel Michael. Interestingly, Joan believed that the voices were those of mere mortals who resided in heaven, except when they were guiding her on earth. She found Michael, in particular, quite a gentleman. After being captured outside Compiégne following her failed attack on Paris, the court trying her decided that she'd never actually been visited by the saints and that her efforts to get Charles VII crowned were the work of the devil. Joan was ultimately burned at the stake for witchcraft in 1431.

As for fallen angels, or demons, who wish to communicate with mortals—well, in many cases, it's mortals who invite them to do so. Psychologists who've dealt with possessed patients agree with Christians that there is a link between staples of the occult like fortune-telling, séances, and Ouija boards, and demonic possession. From the Christian perspective, if you use such items to gain knowledge or power, you're acting as if you are God, not to mention completely cutting him out of the picture. If a Ouija board actually answers your question, and if you aren't playing with someone eager to get a rise out of you, it's likely a spirit communicating with you. Although you may think it's your Great-Grandma Mildred, it's wise to keep in mind that one of the many fortes of Satan and his fallen angels is to pretend to be something they're not.

angel's Curse

This demon, tethered to his post in hell by its very roots, is the embodiment of everything evil and wretched. Writhing in agony, he uses all his might to gain just an inch of freedom. But being a soldier in Satan's army comes at a cost—endless pain and suffering, and the eternal curse of being a permanent denizen of the underworld.

Materials
- Black acrylic paint
- Black gouache
- White gouache
- Black colored pencil
- White colored pencil
- Vellum paper
- Scratch paper
- Two to three small synthetic paintbrushes
- Paper towels
- Old toothbrush
- Bowl of water
- Window cleaner
- Airbrush

◄ **Step One** When clients come to me for a multitude of concepts, and their main focus is on the mood, this is one of the best and fastest techniques to use. Start right off on vellum paper. Draw the angel with a black colored pencil on the far left of the page. Fill the airbrush with mars black acrylic and spray the entire page, at an angle. Still using the airbrush, create a dark frame behind the evil angel.

► **Step Two** This is how I have my table set up for the painting. Use an old board under the painting to protect the table. A piece of scratch paper is ideal for testing the airbrush and setting aside your dirty toothbrush. I couldn't find my paint bowl, so I borrowed by daughter's Halloween cup. At least it fits the mood of the illustration.

◀ Step Three For the angel, switch to black gouache. The reason for using black acrylic for the background instead of gouache is because the acrylic paint will stay in place even when I paint over it with water. Gouache is fugitive, and can be manipulated when touched by water. Using a small synthetic brush, paint in the wings.

▼ Step Four To make the wings more web-like, mix one part gouache to two parts water. Then, paint in the wing, allowing the paint to pool. Next, dab off some of the paint with a paper towel, leaving unique textures and patterns behind.

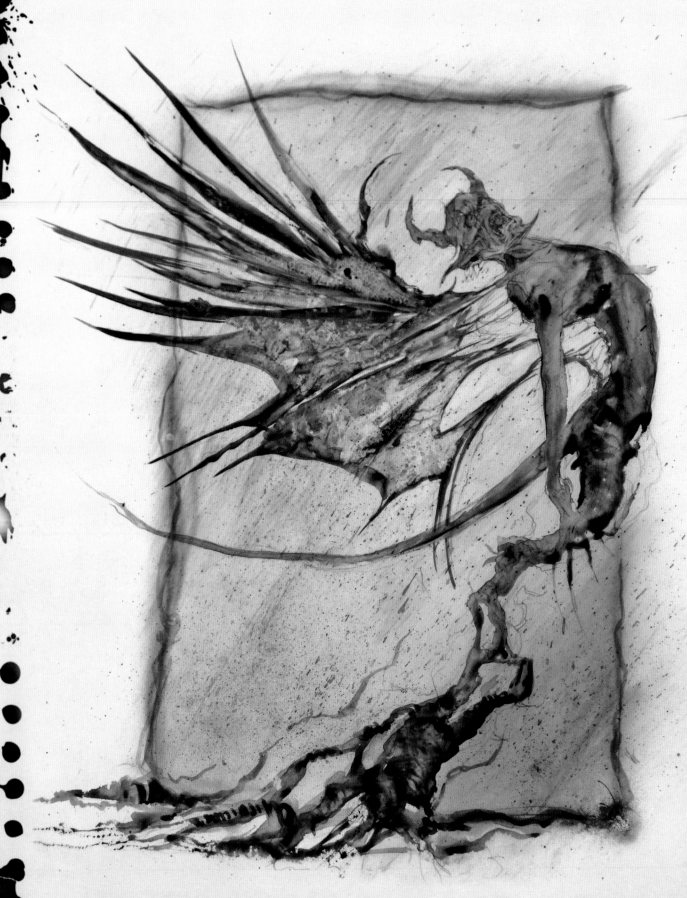

Step Five In this step, we'll paint the rest of the angel using the brush. Notice the gritty texture in the background. You can achieve this look by first dipping an old toothbrush in the gouache. Now, from the bottom, left corner of the paper, flick the paint off the brush to create the texture.

94

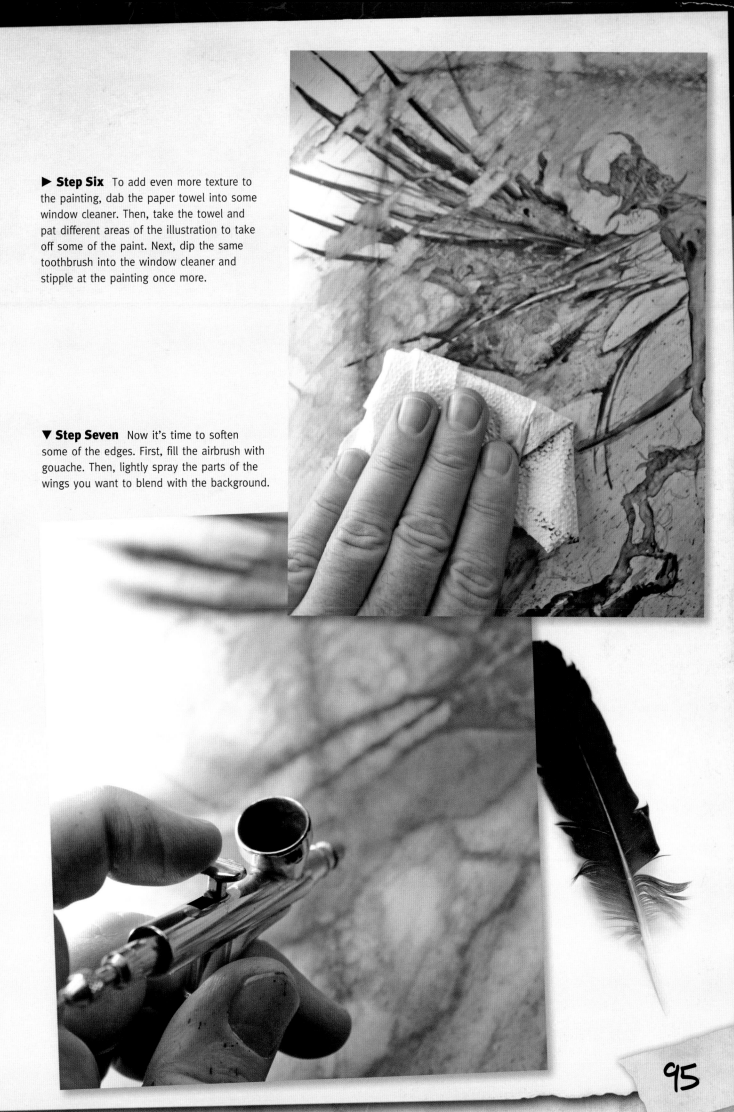

▶ Step Six To add even more texture to the painting, dab the paper towel into some window cleaner. Then, take the towel and pat different areas of the illustration to take off some of the paint. Next, dip the same toothbrush into the window cleaner and stipple at the painting once more.

▼ Step Seven Now it's time to soften some of the edges. First, fill the airbrush with gouache. Then, lightly spray the parts of the wings you want to blend with the background.

▶ **Step Eight** Let's soften the rest of the angel to prepare for the last stage, the highlights and dark accents.

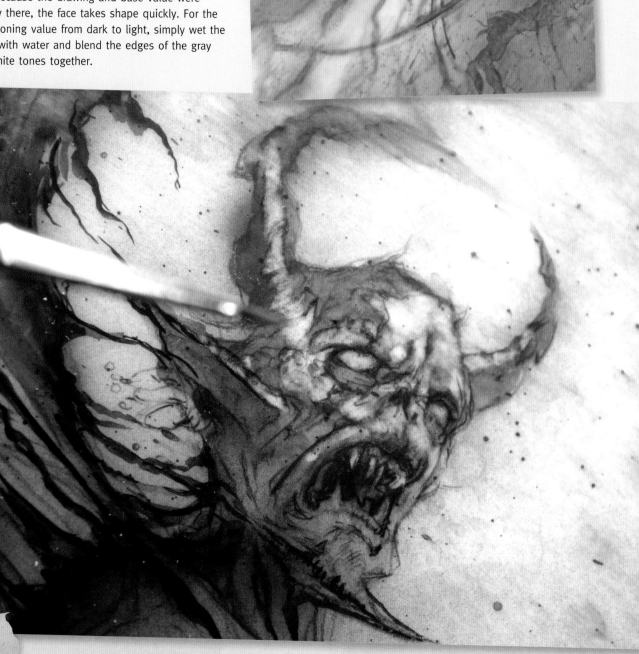

▼ **Step Nine** Using the white gouache and a fine brush, bring out the forms of the screaming face. Because the drawing and base value were already there, the face takes shape quickly. For the transitioning value from dark to light, simply wet the brush with water and blend the edges of the gray and white tones together.

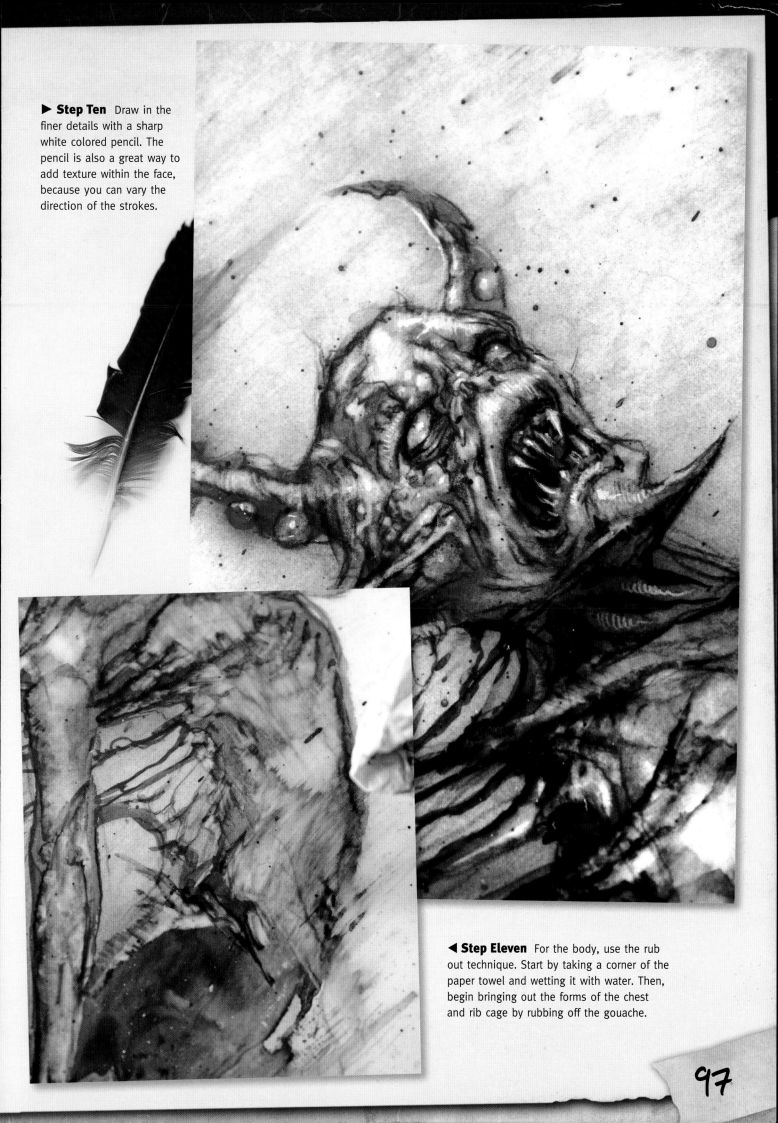

▶ **Step Ten** Draw in the finer details with a sharp white colored pencil. The pencil is also a great way to add texture within the face, because you can vary the direction of the strokes.

◀ **Step Eleven** For the body, use the rub out technique. Start by taking a corner of the paper towel and wetting it with water. Then, begin bringing out the forms of the chest and rib cage by rubbing off the gouache.

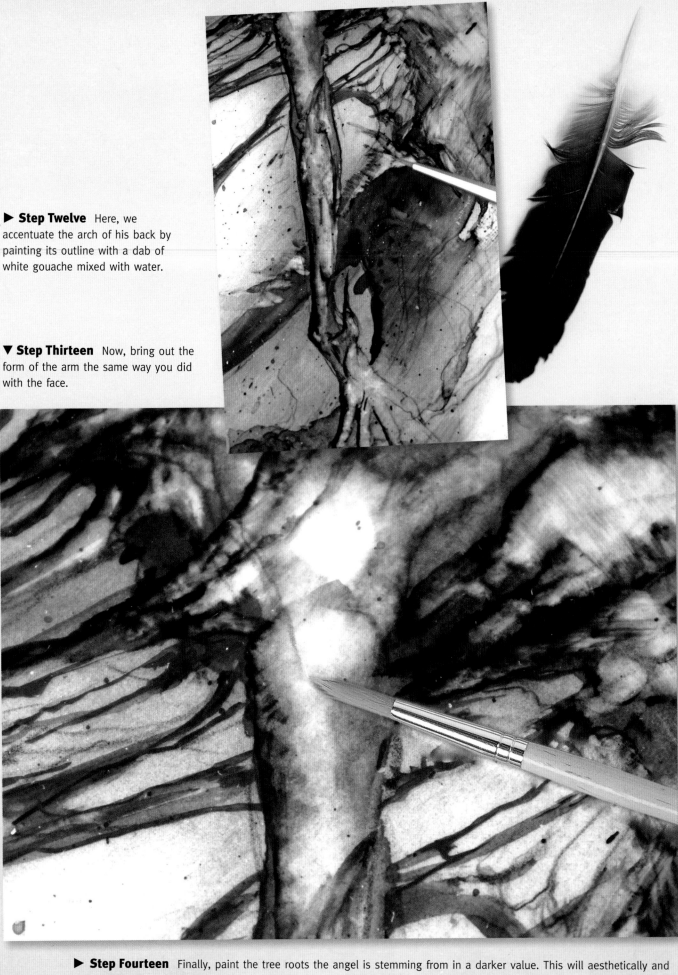

▶ **Step Twelve** Here, we accentuate the arch of his back by painting its outline with a dab of white gouache mixed with water.

▼ **Step Thirteen** Now, bring out the form of the arm the same way you did with the face.

▶ **Step Fourteen** Finally, paint the tree roots the angel is stemming from in a darker value. This will aesthetically and compositionally ground the painting.

98

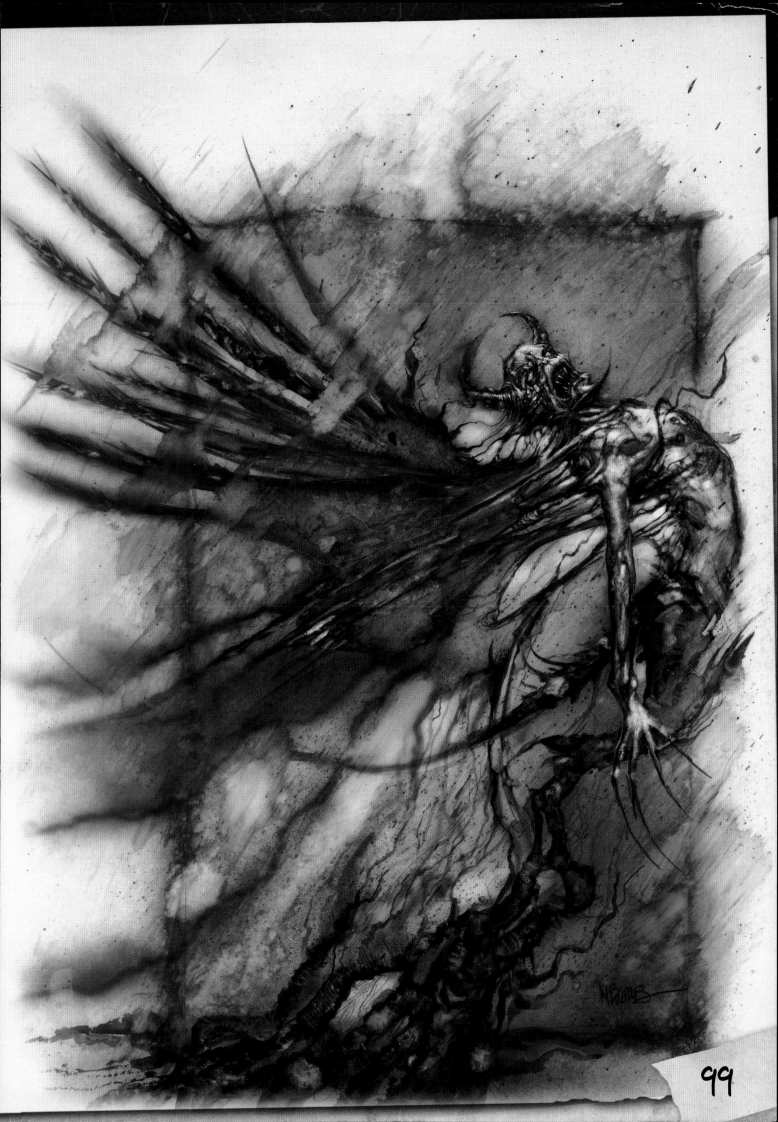

Chapter 4: digital illustration

digital illustration materials

Digital illustration can result in highly detailed, fiercely dynamic artwork. Unlike drawing or painting, digital illustration allows you to make dramatic enhancements with just a few clicks of a button. Before working on the projects in this chapter, note that it's important to have an understanding of the basic tools and functions of your image-editing software (I prefer Photoshop®). However, if you don't have a background in digital illustration, you can still use these projects as references for drawing or painting—each piece of art begins with a drawing or painting by hand.

Black Colored Pencil

Tracing Paper

Vellum Paper

Materials Checklist

To complete the illustration projects in this book, you'll need to purchase the materials below. Note that the exact materials needed for each project are listed at the start of each project:

- Black colored pencil
- Tracing paper
- Vellum paper
- Workable spray fixative
- Computer system and Photoshop®
- Scanner

Computer System

To embark on your journey in digital illustration, you'll need a computer system, a scanner, and image-editing software. In the setup at right, you'll see that you can configure multiple monitors for one computer system. This can help you spread out your work; you can bleed the monitors so that your image crosses over onto multiple screens, allowing you to see much more of the image at once. You can also use the multiple monitors to hold various control panels, so you aren't constantly minimizing windows to create room on the screen. Although it's ideal to work with several monitors, all you really need is one.

Image-Editing Software

There is a variety of image-editing software available, but many would agree that Adobe® Photoshop® is the most widely used. Below are short summaries of some basic functions used in the projects throughout this book.

Photoshop Basics

Image Resolution: When scanning your drawing or painting into Photoshop, it's important to scan it at 300 dpi (dots per inch) and 100% the size of the original. A higher dpi carries more pixel information and determines the quality at which your image will print. However, if you intend for the image to be a piece of digital art only, you can set the dpi as low as 72. View the dpi and size under the menu Image › Image Size.

Levels: With this tool (under the menu Image › Adjustments), you can change the brightness, contrast, and range of values within an image. The black, midtone, and white of the image are represented by the three markers along the bottom of the graph. Slide these markers horizontally. Moving the black marker right will darken the overall image, moving the white marker left will lighten the overall image, and sliding the midtone marker left or right will bring the midtones darker or lighter, respectively.

Dodge and Burn Tools: The dodge and burn tools, terms borrowed from the old dark room, are also found on the basic tool bar. Dodge is synonymous with lighten, and burn is synonymous with darken. On the settings bar under "range," you can select highlights, midtones, or shadows. Select which of the three you'd like to dodge or burn, and the tool will only affect these areas. Adjust the width and exposure (or strength) as desired.

Eraser Tool: The eraser tool is found in the basic tool bar. When working on a background layer, the tool removes pixels to reveal a white background. You can adjust the diameter and opacity of the brush to control the width and strength of the eraser.

Paintbrush Tool: The paintbrush tool, on the basic tool bar in Photoshop, allows you to apply layers of color to your canvas. Like the eraser, dodge, and burn tools, you can adjust the diameter and opacity of the brush to control the width and strength of your strokes.

Color Picker: Choose the color of your "paint" in the color picker window. Select your hue by clicking within the vertical color bar; then move the circular cursor around the box to change the color's tone.

Wingless

From afar, she has the hair and curves of a catwalk icon, not to mention the face of a screen siren. But as you draw nearer, unable to resist her seductive aura, the horror of her past becomes painfully apparent. Stitches hastily inserted into wounds where wings once were and claw marks etched down her face reveal that she's far from a heavenly creature. She's done some evil. And she wears her scars proudly.

Materials
- Vellum paper
- Black colored pencil
- Photoshop®

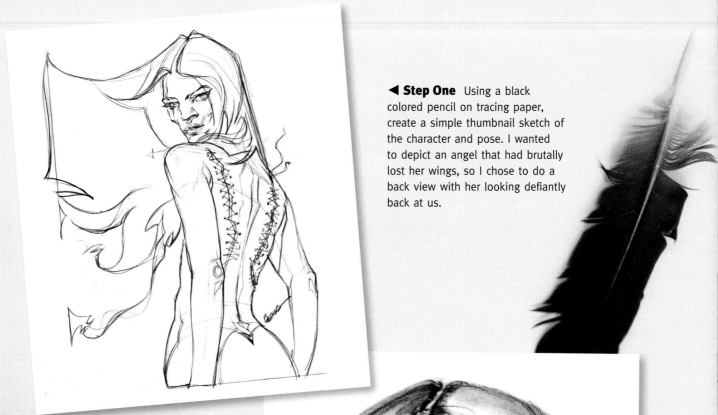

◄ **Step One** Using a black colored pencil on tracing paper, create a simple thumbnail sketch of the character and pose. I wanted to depict an angel that had brutally lost her wings, so I chose to do a back view with her looking defiantly back at us.

► **Step Two** This dark angel is beautiful, but in a terrifying sort of way. Her proportions aren't those typical of a supermodel. And the spacing and size of her features are distorted just enough to bring discomfort to the viewer. Use quick, graphic pencil strokes to chisel her face. Try to achieve a gaunt, almost scarred appearance.

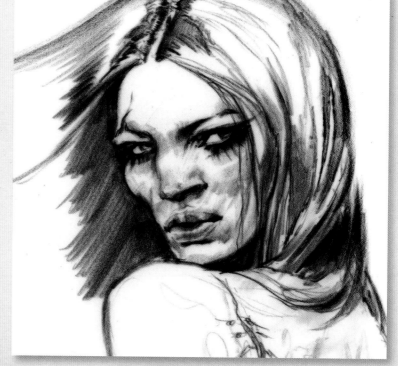

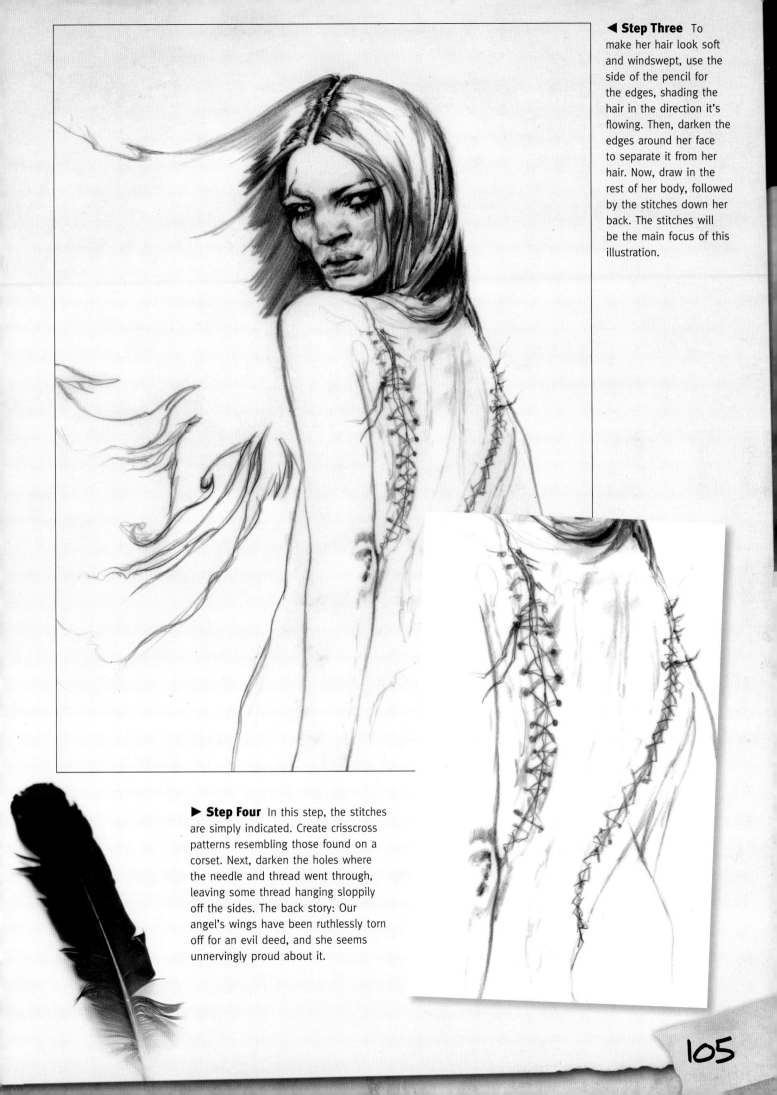

◄ Step Three To make her hair look soft and windswept, use the side of the pencil for the edges, shading the hair in the direction it's flowing. Then, darken the edges around her face to separate it from her hair. Now, draw in the rest of her body, followed by the stitches down her back. The stitches will be the main focus of this illustration.

▶ Step Four In this step, the stitches are simply indicated. Create crisscross patterns resembling those found on a corset. Next, darken the holes where the needle and thread went through, leaving some thread hanging sloppily off the sides. The back story: Our angel's wings have been ruthlessly torn off for an evil deed, and she seems unnervingly proud about it.

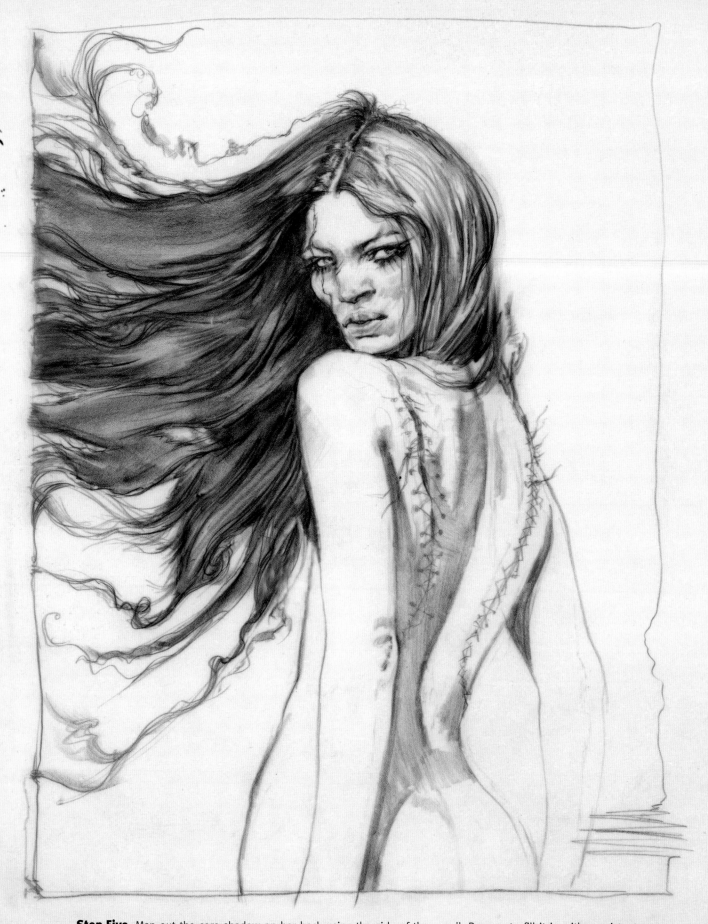

Step Five Map out the core shadow on her back using the side of the pencil. Be sure to fill it in with consistent strokes so as not to distract the eye. I was able to come up with this angel using reference pictures from past photo shoots. Her face was inspired by different female faces I liked, but I added my own twist. Because of the stitches, I had to invent the majority of the shadow pattern on her back. Again, if you're uncomfortable inventing a figure or inventing the lighting, don't hesitate to photograph yourself or a friend. A model with the exact physique you want isn't necessary, because you can always distort or exaggerate the form afterward.

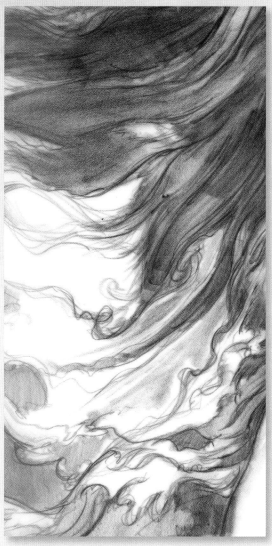

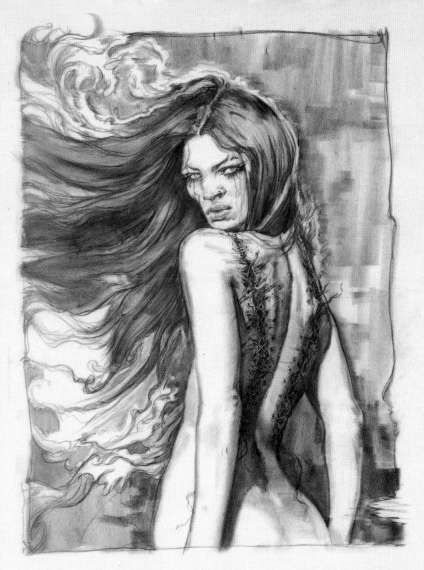

▲ **Step Six** The hair should look as if flames are swirling around her. When designing it, curl the ends and keep them white hot. For the background, use the side of the pencil to make quick, uneven strokes. This suggests an environment in motion.

▲ **Step Seven** Continue by treating the stitching down her back as if it's a series of core shadows. Make sure that the stitches are a little darker than the rest of the area. This also creates a very uncomfortable visual, because it appears as if the skin wasn't sown together tightly enough. The threads are a few shades lighter but are outlined with a darker value to make them appear painfully thick and three-dimensional.

◄ **Step Eight** Now, the drawing is ready to be scanned into Photoshop®, where we'll add color.

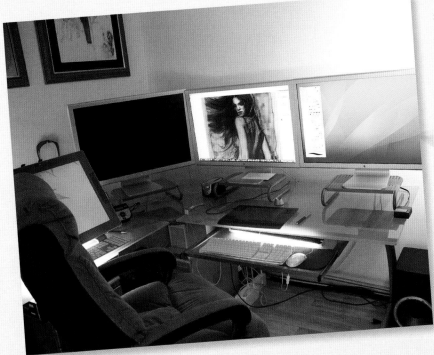

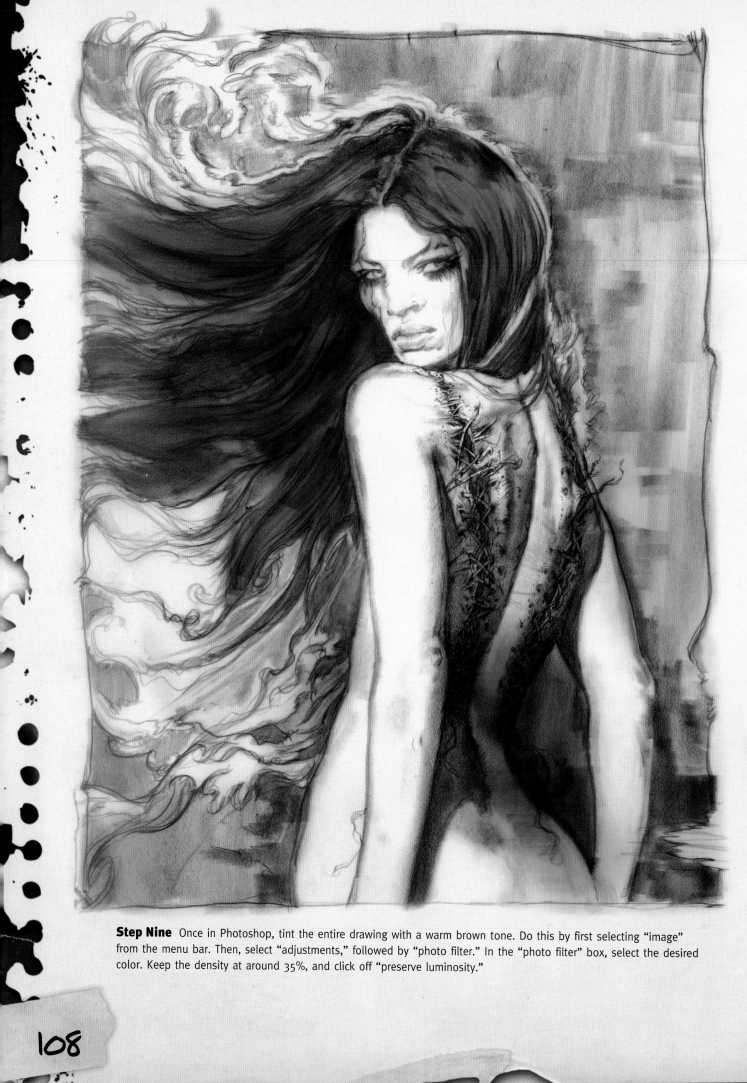

Step Nine Once in Photoshop, tint the entire drawing with a warm brown tone. Do this by first selecting "image" from the menu bar. Then, select "adjustments," followed by "photo filter." In the "photo filter" box, select the desired color. Keep the density at around 35%, and click off "preserve luminosity."

◀ **Step Ten** Next, start to work on the face. Ultimately, we want it to end up pale, with deathly blue tones. The most-used tools in this step are the eraser, brush, and burn tools. Always keep their opacity and exposure levels at around 25% to control the layering of the colors. Beginning with her face, use the eraser tool. Again, keep the opacity level low for increased transparency.

◀ **Step Eleven** To create the demonic effect of her eyes, use the brush tool and lower the diameter to about 3px. Then, select a dark turquoise color from the palette and outline the eyes. Next, choose a warm black, decrease the diameter to 2px, and go over the turquoise. For the inner rim of the eyes, select a pinkish red to offset the dark, cool outline. Now, use the eraser tool for the white of the eyes.

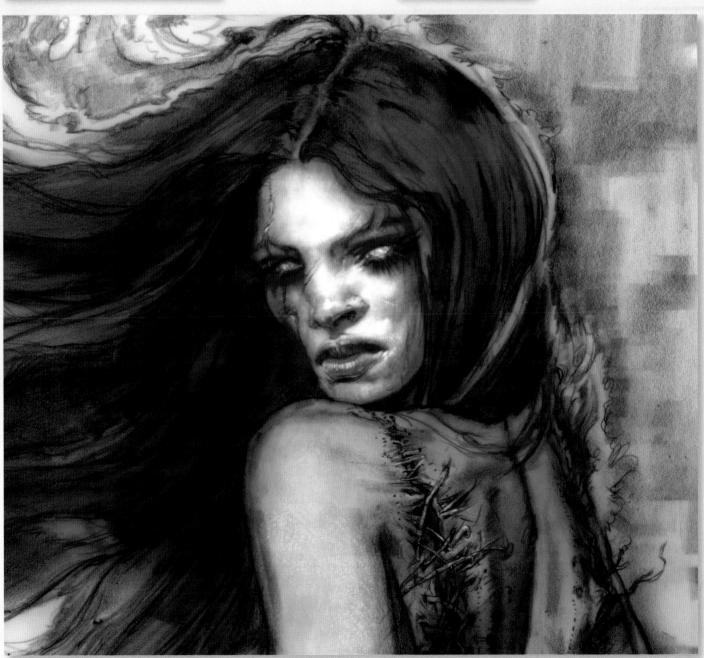

▲ **Step Twelve** Although we want her skin tone to be cool and pale, it would be uninteresting without some warm colors in it for contrast. Select a terracotta color from the palette. Then, use the paintbrush tool to paint in the lips, around the eyes, cheeks, and tip of the nose. Return to the colors and choose a greenish-blue for the areas that should recede, like the philtrum and jawline. Again, remember to keep the opacity low, so that you can control the layering of colors. Notice the way I added some light-valued strokes all over her face. It's the same technique I use when drawing with a pencil. I do this to add texture when it begins to look too smooth.

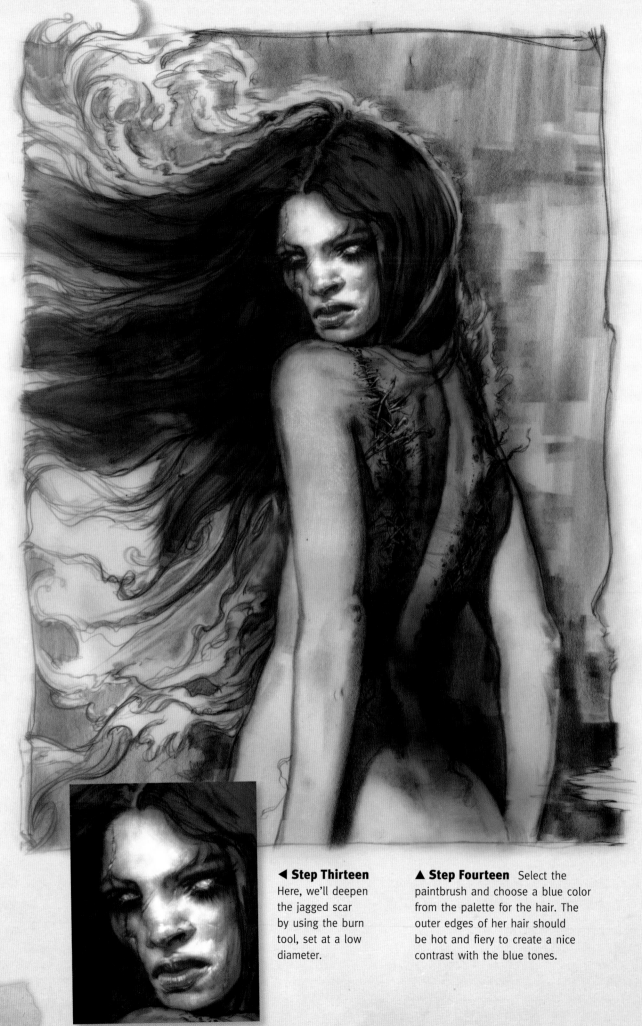

◄ **Step Thirteen**
Here, we'll deepen
the jagged scar
by using the burn
tool, set at a low
diameter.

▲ **Step Fourteen** Select the
paintbrush and choose a blue color
from the palette for the hair. The
outer edges of her hair should
be hot and fiery to create a nice
contrast with the blue tones.

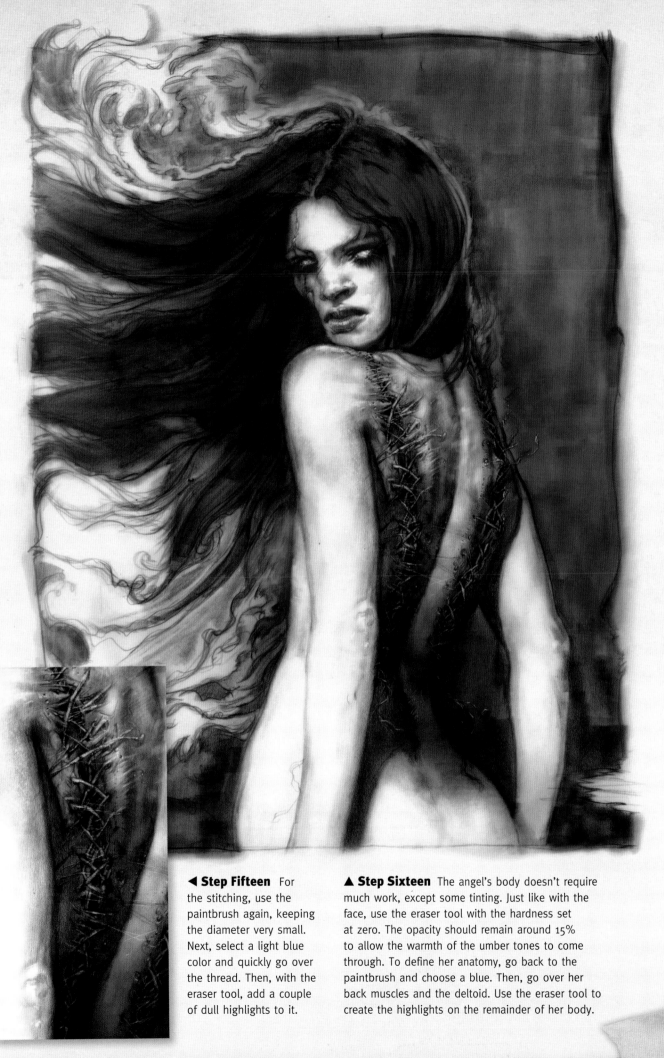

◀ **Step Fifteen** For the stitching, use the paintbrush again, keeping the diameter very small. Next, select a light blue color and quickly go over the thread. Then, with the eraser tool, add a couple of dull highlights to it.

▲ **Step Sixteen** The angel's body doesn't require much work, except some tinting. Just like with the face, use the eraser tool with the hardness set at zero. The opacity should remain around 15% to allow the warmth of the umber tones to come through. To define her anatomy, go back to the paintbrush and choose a blue. Then, go over her back muscles and the deltoid. Use the eraser tool to create the highlights on the remainder of her body.

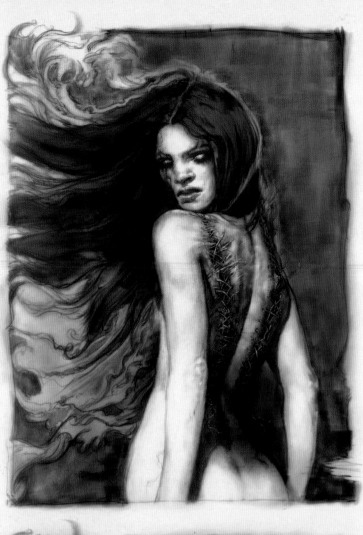

Step Seventeen I wanted the hair to look almost as if it'd been caught in a cloud of smoke and flames. The preliminary drawing did most of the work for the smoky effect. To make the narrow rim lighting of her hair appear glowing with heat, first select the paintbrush tool. Then, in the options found under "mode," choose "soft light." Next, select an orange from the color palette and paint the rim of the hair.

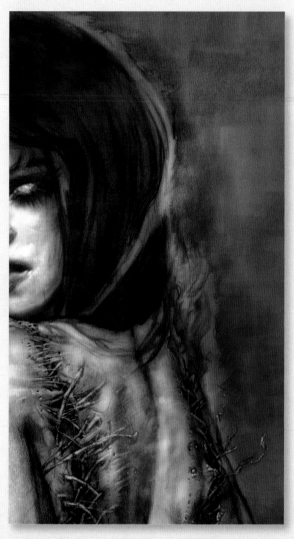

▲ Step Eighteen Fire isn't one color, so the rim light shouldn't be either. To mix it up, choose a deeper red from the palette for the other parts of the outline.

◄ Step Nineteen Use a subdued purple for the bottom part of the flowing hair to complement the yellow and orange color families. To prevent it from being garish, make sure it's grayed down and transparent. Do this by using the paintbrush tool with the "mode" set on "multiply." Now, use this same color to paint the side of her breast and forehead. This helps tie together the angel and the background.

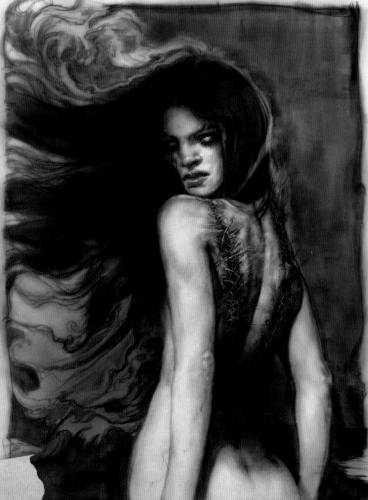

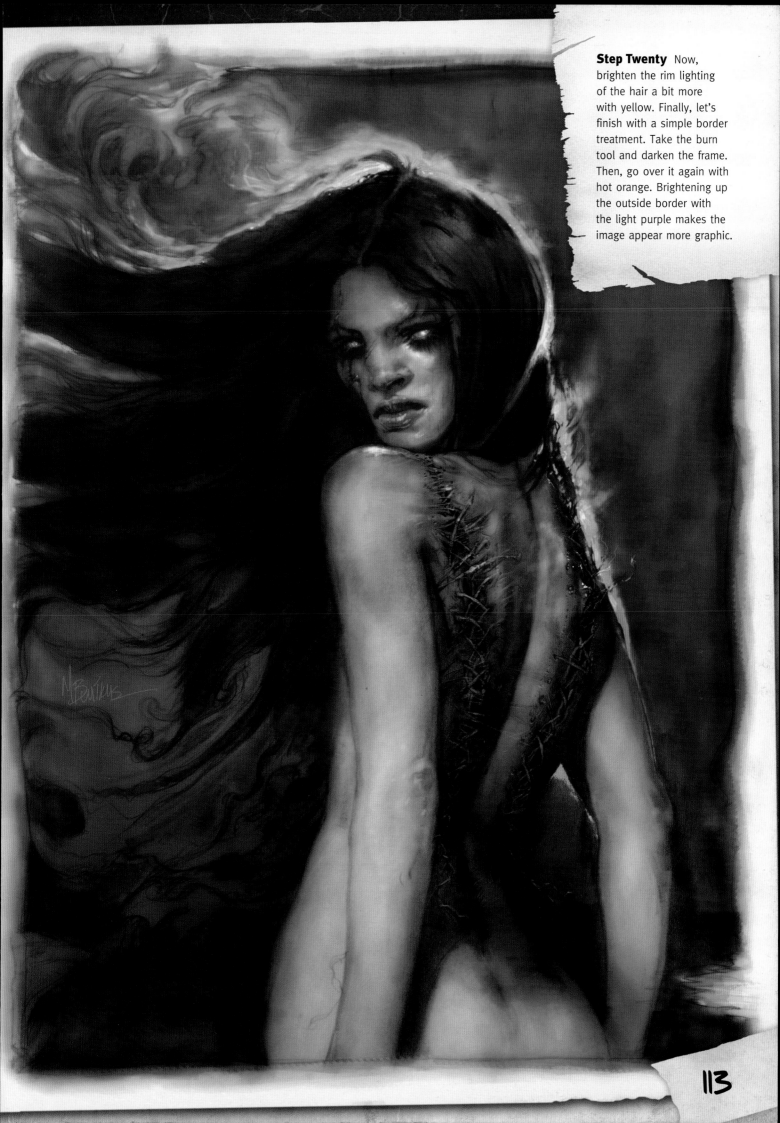

Step Twenty Now, brighten the rim lighting of the hair a bit more with yellow. Finally, let's finish with a simple border treatment. Take the burn tool and darken the frame. Then, go over it again with hot orange. Brightening up the outside border with the light purple makes the image appear more graphic.

addicted to angels

Dark Stars of Literature

It's no surprise that our fascination with angels, especially the wayward, fallen variety, has seeped out of our collective imagination into our favorite forms of entertainment. Do a search on your favorite book-buying Web site, and you'll receive nearly 1,000 results—and that's only for fallen angels. Contemporary writers of nonfiction, romance fiction, young adult novels, graphic novels, and manga have resurrected angels from the resting place they retreat to when they're out of fashion and have made them shine again.

Here's a list of required reading for up-and-coming angelogists or anyone drawn to dark places:

Mercury Falls by Robert Kroese

The *Fallen Angel Omnibus* graphic novel series by Peter David and J.K. Woodward

The *Fallen* series by Lauren Kate

Halo by Alexandra Adornetto

Hush, Hush by Becca Fitzpatrick

The *Battle Angel Alita, Last Order* manga series by Yukito Kishiro

Memnoch the Devil by Anne Rice

Hellraiser by Clive Barker

Something Wicked This Way Comes by Ray Bradbury

The Screwtape Letters by C.S. Lewis

The Devil and Daniel Webster by Stephen Vincent Benét

Our Town by Thornton Wilder

The Sorrows of Satan by Marie Corelli

Faust by Johann Wolfgang von Goethe

Ambrosio, the Monk by Matthew Lewis

Paradise Lost by John Milton

The Faerie Queene by Edmund Spenser

The Divine Comedy by Dante Alighieri

Beowulf

Angels on the Airwaves

Don't think for a second that ditties about fallen angels are restricted to goth bands. From country singer Patty Loveless ("When Fallen Angels Fly") and pop artist Chris Brown ("Fallen Angel"), to rock superstars Aerosmith ("Fallen Angels") and Rap giant Jay-Z ("Lucifer"), recording artists are well-versed at paralleling tales of the down-and-out with fallen angels in their lyrics. Putting a slight twist on the theme, Australian band Real Life's video for their 1983 hit "Send Me An Angel" features a damsel cloaked in black carrying her handy pet owl in a seemingly disoriented fashion through the misty forest. Meanwhile, a werewolf on horseback is clearly hot on her tracks. Send me an angel, indeed! If you don't know the video, you'll be happy to learn that an androgynous archer, who we can only assume is a good angel, sends an arrow through the werewolf, after which a fawn passes by, and all is right in the woods once again.

The songs about, or referring to, angels in an uplifting sense are countless. There are such classic carols as "Angels We Have Heard on High" and

"Hark the Herald Angels Sing," as well as "Angel" by Madonna and yet another tune about celestial beings from Aerosmith, also appropriately titled "Angel." The country crooners have a slew of them: The Judds' "Guardian Angels," Mindy McCready's "Ten Thousand Angels," and "The Angels Rejoiced Last Night" by Gram Parsons are only a few.

People who make it a point to connect with angels on a daily basis suggest that an angel may be in your midst if a song that inexplicably tugs at your heartstrings plays on the radio. That may or may not be fact, but what is certain, is that if you're tuned into a country station, you're going to feel blessed for a while.

Filming the Fallen Angel

Like happy angel songs, comedies and inspiring films about good angels abound. Among the most popular are holiday classics *It's a Wonderful Life* (1946) and *The Bishop's Wife* (1947); eighties staples *The Heavenly Kid* (1985) and *Always* (1989); and several in the nineties (due in part to angels' resurgence in pop culture at the time), including the remake of *Angels in the Outfield* (1994), *Michael* (1996), and *A Life Less Ordinary* (1997).

Because depicting the world that surrounds fallen angels, their transformation, or their all-around hideousness, is so much fun for filmmakers, the list of demon-filled viewing options is bountiful. This is just a handful:

The Rite (2011)
The Ninth Gate (1999)
What Dreams May Come (1998)
The Devil's Advocate (1997)
The Prophecy (1995)
Needful Things (1993)
Angel Heart (1987)
The Omen (1976)
The Exorcist (1973)
The Stranger Within (1974)
Rosemary's Baby (1968)
Dante's Inferno (1935)

graffiti angel

He fell from grace, but not from heaven to hell. Before life got rough, he was a good kid with noble intentions. Then, the demons hidden deep within overcame him, making his existence a living hell. Now, when they try to reemerge and wreak havoc, he exorcises them with a spray can. Now . . . his future is written on the wall.

Materials
- Vellum paper
- Black colored pencil
- Tracing paper
- Photoshop®

◄ **Step One** I've always been an admirer of well-executed graffiti art, and would rather see that than a plain and dreary overpass any day. This was my original thumbnail on tracing paper. This graffiti artist had a rough and undesirable past, but through his newfound passion for graffiti art, he redeemed himself and earned his artistic wings.

▶ **Step Two** I wasn't completely satisfied with my original sketch. After several different variations, I decided on this one and redrew the final using black colored pencil over vellum. This graffiti artist is bigger and slightly more aggressive. The artwork on the wall is simpler, and the wings have more presence after being brought in. Overall, the composition is cleaner and much easier to understand.

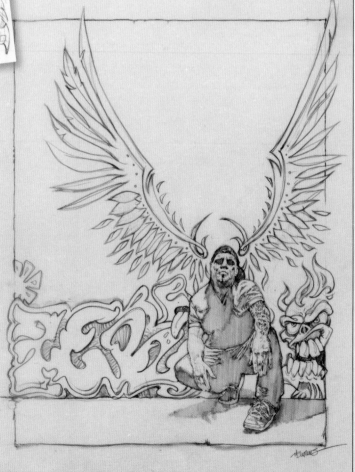

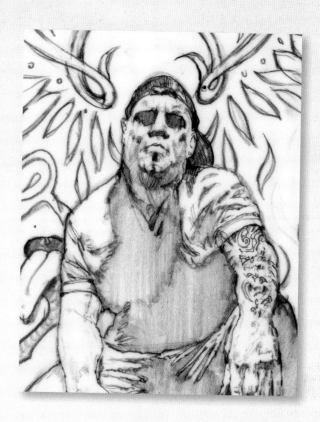

▶ Step Three The artist looks like an average-looking guy you'd see walking down the street but with a bit of edge. His edginess is apparent in his confident body language, the graphic lighting, and the tattoos on his left arm. He's mostly in shadow, but is lit by a single light source from above. This made it easier for me to invent the figure. Now, the drawing is ready to be painted in Photoshop®.

◀ Step Four After the drawing is scanned, experiment with its colors by selecting "color balance," found under "adjustments," and choosing a warm sepia tone. In the end, I thought the cool gray tones worked better here, so I stuck with the original black and white.

▶ **Step Five** The Internet is a wonderful resource for artists. This brick wall texture is from a Web site full of free wall textures. After choosing a texture, drop the file into Photoshop. Next, cool down the colors of the wall to a subdued gray using "color balance." Then, select "filters" from the toolbar, and choose "artistic," followed by "paint daubs." This filter took away some of the realism from the texture. Now, it'll be easier to blend it in with the drawing.

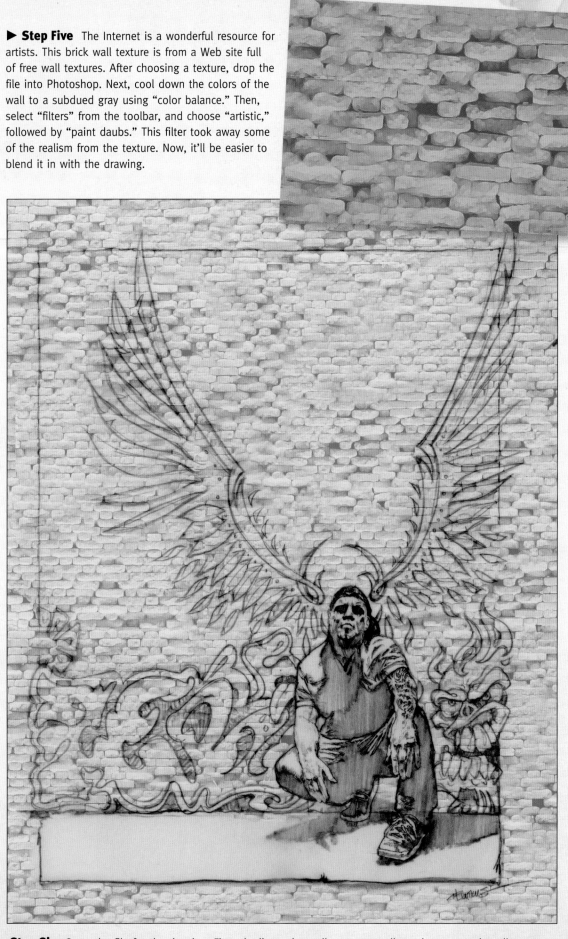

Step Six Open the file for the drawing. First, duplicate the wall textures until you have enough wall space for the drawing. Then, select the drawing and place it over the textures. Next, select the eraser tool, keeping the opacity at 20% and the hardness at zero. Begin erasing the drawing until the right amount of texture comes through. Try to avoid the character and the ground. To merge the texture and drawing together so you can work on it, select "multiply" from the "layers" menu.

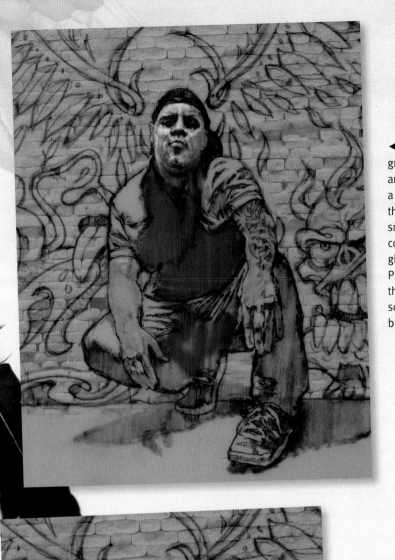

Step Seven In this step, we'll paint the graffiti artist. Start by zooming in on his face and selecting the paintbrush tool. Now, pick a base skin tone (as seen on his arms) from the color palette. Keep the brush size relatively small and the opacity at 20%. Letting the gray colors and the line drawing show through gives the overall illustration an editorial look. Pick a warm beige from the palette to paint the facial planes that would be hit by a light source. Then, paint the eye sockets a dark burnt umber.

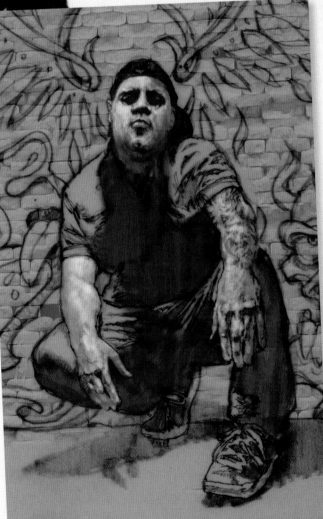

Step Eight Smooth out the face a little more with a medium beige value. Then, take the same color and bring out the muscles and highlights down his arms.

119

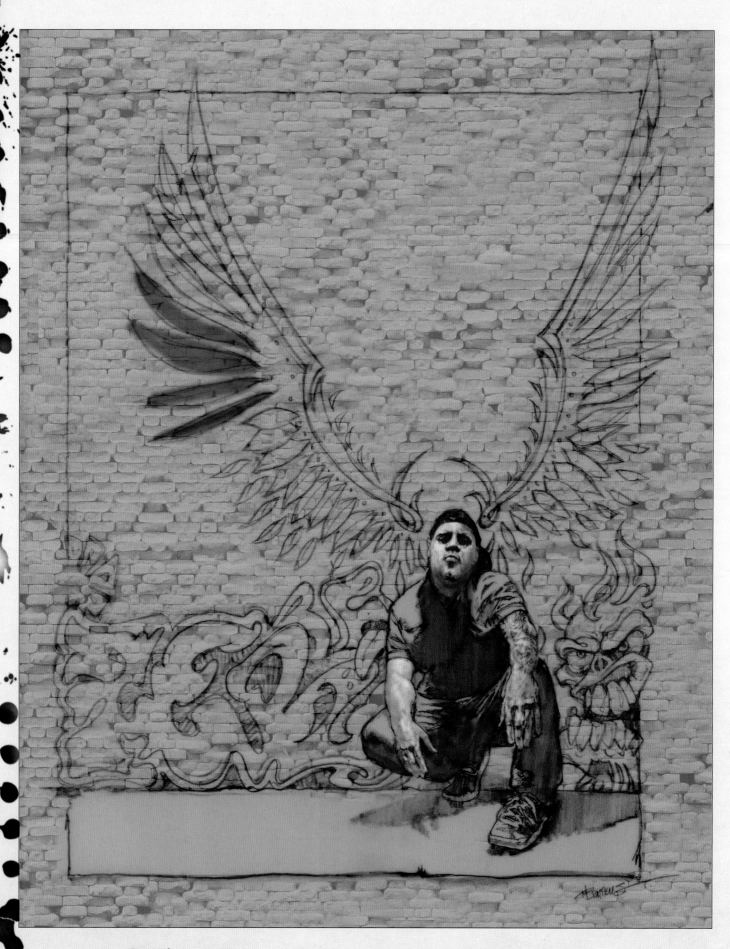

Step Nine Here, the same navy blue is used for the shadows of his clothes and the wings. Remember to keep the opacity level low to let the texture of the bricks show through.

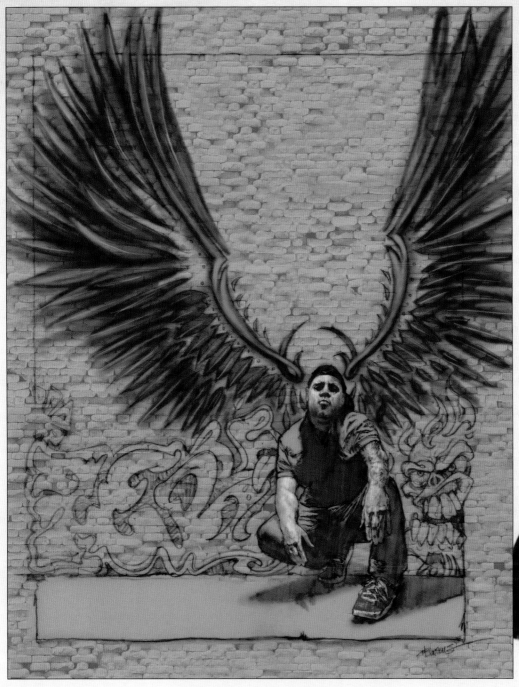

◄ **Step Ten** Use subdued tones of blue, lavender, and black to keep the wings monochromatic. Because his foot is coming forward, I decided to give him a splash of color by painting his canvas shoes red.

▶ **Step Eleven** All the color is dedicated to the graffiti art. When working on a project like this, it's necessary to view many different kinds of graffiti images to see what you're drawn to. I was attracted to the big, bold lettering that seemed to flow into one eye-catching design. I attempted to create some of my own, starting off with a cheerful yellow. Over the yellow, we'll add other bright colors that will seamlessly blend into each other.

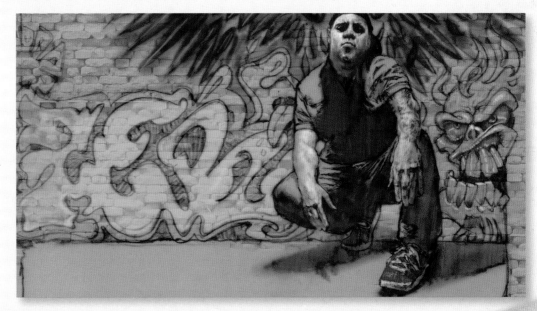

► **Step Twelve** To get the paint looking like it was spray painted on the wall, keep the opacity at about 20% and the hardness level to a zero. Choose colors that complement each other, like oranges, blues, greens, and yellows. Just make sure that they're all the same value. Then, lightly outline them to give them dimension.

◄ **Step Thirteen** The monster in the background represents the graffiti artist's past. Notice the way he glares directly at his creator. This artistic angel is compelled to integrate a demon into all of his artwork to remind him of the mistakes he won't repeat. The same colors used for the lettering are used for the monster, except for some darker shadows added to his eyes and mouth.

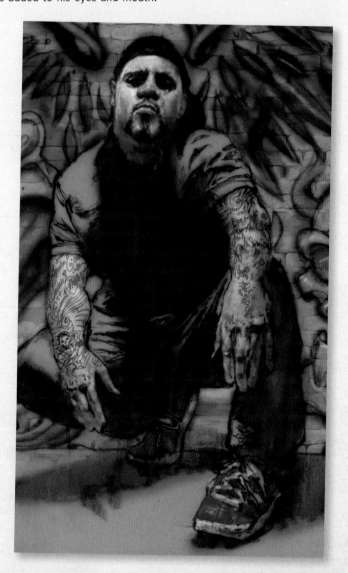

▲ **Step Fourteen** The angel's face looked a little too round and soft. The quickest way to toughen him up was to add a goatee. Using the paintbrush tool like a pencil, lower the diameter to 3 px. Choose a dark gray from the color palette and draw in the moustache and the hair on the top plane of his chin. Now choose a darker color, close to black. Draw in the rest of the goatee and follow the form of his face.

► **Step Fifteen** Here, we're tattooing his right arm to balance his right side. With a small paintbrush tool, select a medium gray and quickly draw in designs that follow the anatomy. The tattoos should look like they were done at different times, but still look like they flow together.

► **Step Sixteen** In this last step, let's lighten up the border so that the image appears to be popping off the page. Select the eraser tool, keeping the opacity at about 30%. Then, simply go around the entire frame.

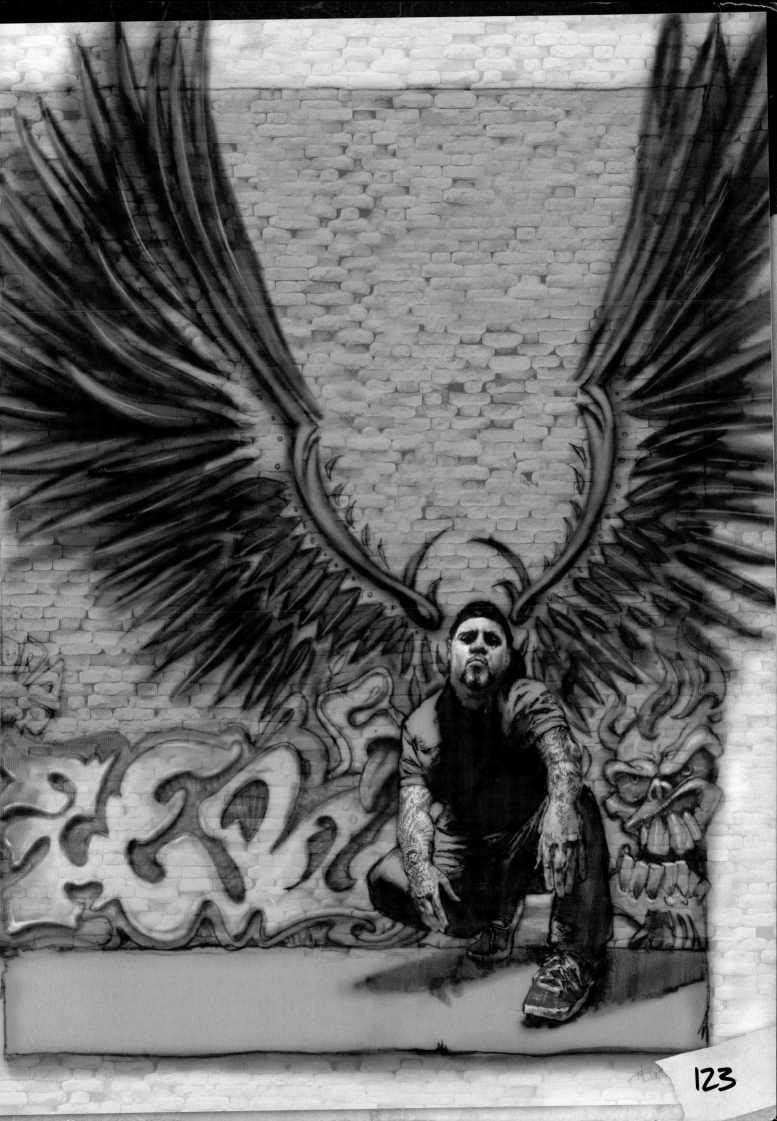

an abbreviated angel glossary

A

angel *Angel* is derived from the Greek *angelos,* or messenger. Angel translates to *malakh* ("messenger") in Hebrew and *angaros* ("courier") in Persian. All translations reflect angels' obligation to traverse between heaven and earth, relaying messages between humans and God. It is also their duty to carry out God's will, whether that means helping or punishing humankind.

Angel of Death That everyone born into the world will at some point cease to exist is the message the Angel of Death must convey. Although some angels, namely Satan, or Samael in Rabbinical mystical tradition, derive pleasure from delivering news of imminent death and taking the soul to heaven or hell, other more esteemed angels have also acted as angels of death, including archangels Gabriel and Michael.

angelophany When a human detects the presence of an angel with one or more of the five senses.

angels of destruction Whether delivering adversity, plague, or death, angels of destruction carry out God's orders to destroy the wicked. Some believe angels of destruction reside in hell and are called upon by God to use their powers for retribution. Although such angels are not typically named in accounts of destruction, the archangel Gabriel is often credited with destroying Sodom and Gomorrah.

angels of the presence Protectors of cosmic secrets, the angels of the presence commanded Moses to write every word God spoke when Moses was atop Mt. Sinai. There are said to be twelve angels among this high-ranking group, including Metatron, Michael, and Uriel.

Ariel Meaning "lion of God," Ariel is one of seven ruling angels in Jewish folklore. The Bible refers to Ariel in the book of Isaiah, however not as an angel, but another name for Jerusalem.

Asmodeus As far as fallen angels go, the three-headed Asomdeus is considered the most vile and vengeful, with a penchant for demonic possession and ruining new marriages by preventing relations between man and wife and luring husbands into adulterous situations. With a cock's feet and tatty wings, he rides atop a dragon and breathes fire.

Astaroth Astaroth's identity varies. In one account, he is the evil alter ego of the goddess Astarte who wields a viper in his left hand as he rides a dragon and promotes idleness. Hebrew lore says he was once a prince of thrones who was exiled from heaven along with Satan.

Azazel Azazel ("God strengthens") is one of two hundred watchers, or angels who fell out of God's favor when they mated with mortal women, according to the apocryphal Book of Enoch. Judaic tradition describes him as a demon with 7 serpent heads, 14 faces, and 12 wings. In Islamic lore, he is turned into Iblis after God banishes him from heaven for refusing to bow before Adam.

B

Beelzebub In Christian teachings, Beelzebub ("lord of the flies") ranked second in the hierarchy of fallen angels, just below Satan, while the Kabbalah dubbed him the prince of demons. Interestingly, he was originally a Syrian god.

Behemoth Literally an enormous demon, Behemoth is often depicted as an elephant who shuffles around on two feet, weighed down by his large midsection, but is also characterized as a crocodile or a whale. He was appointed infernal watchman in Satan's court and oversaw the great feasts in hell.

Belial One of Satan's most indispensable underlings, Belial is a fallen angel who is every bit malicious as he is deceptively beautiful and soft-spoken. In ancient Hebrew lore, Belial was created after Lucifer and was born evil. His mission is to fuel sinfulness and guilt in humankind.

C

cherubs In modern English, *cherubs* connote the winged babies and toddlers so prevalent around Valentine's Day. Those feathered tykes are actually called *putti*, however, and the sphinx-like winged creatures who rank second in the hierarchy of angels are called *cherubim*.

choirs The hierarchical organization of angels into tiers and groups. It is widely accepted that there are nine choirs, or groups, situated into three tiers.

D

daemon Every person had his own attendant spirit called a *daemon* ("divine power") that guided and protected him throughout life, according to the ancient Greeks. If an answer was needed, the daemon provided a sudden wave of intuition. But daemons also inflicted punishment upon mortals if they disregarded the daemon's subconscious suggestions.

days of the week In occult magical lore certain angels are associated with days of the week: Michael is the chief angel for Sunday; Gabriel for Monday; Samael for Tuesday; Raphael for Wednesday; Sachiel for Thursday; Anael for Friday; and Cassiel for Saturday.

dreams As the spiritual embodiments of divine wisdom, angels often appear in dreams to relay critical information to the dreamer. In the Gospel of Matthew, Joseph, who has decided to divorce Mary upon learning of her pregnancy, is visited by an angel in his dream who assures him that Mary's unborn child is of the Holy Spirit.

E

elemental Elementals exist as purveyors of harmony in the natural world. Ruled by angels, they are said to preside over earth, air, fire, and water; the planets and stars; the signs of the zodiac; day and night; and animals, plants, and minerals, according to magical lore.

Enoch Legend dictates that Enoch was a prophet taken to heaven by God's decree. There he became the archangel Metatron and served as a holy scribe. His experience with the various angels populating heaven and hell was chronicled in the Book of Enoch, allegedly by Enoch himself, although it is argued that several authors wrote the book anonymously during the last two centuries B.C.

F

feather crown Also known as an angel wreath, a feather crown is a wreath-shaped lump of feathers found inside bed pillows. According to folklore, if a feather crown is found inside the pillow of someone recently deceased, it's good news; it means that person is on his or her way to heaven.

flaming swords Genesis 3:24 recounts how God blocked access to the Garden of Eden with "cherubim" and a "flaming sword which turned every way." Because of this, it is common for angels to be accompanied by flaming swords in works of art.

G

Gabriel Gabriel means "God is my strength" or "man of God"—an appropriate description of the archangel who sits at the left hand of God and serves as God's messenger throughout scripture in the three major Abrahamic religions. Only he and Michael are identified as angels by name in the Old Testament.

H

halo The halo, or nimbus, symbolizes closeness to God and the divinity that radiates from within as a result. It became a fixture in representations of angels in art by the fourth century A.D.

hell The "house of woe and pain," as John Milton described it, hell is the eternal realm of Satan, his legion of fallen angels, and the souls of the damned.

I

Iblis The equivalent of Satan in Persian and Arabic lore, and the once-exalted but castoff angel formerly known as Azazel in Islamic lore.

Israfil Meaning "the burning one," Israfil will blow the trumpet on Judgment Day, according to Islamic lore. He is the angel of resurrection.

J

Jacob's ladder Appearing in Genesis 28:11–19, Jacob's Ladder is a ladder (or a stairway in some translations) to heaven that Jacob envisioned angels ascending and descending as he slept on a stone pillow in the wild during his flight from his brother Esau. God proclaimed from above the ladder that He would renew His promise to Jacob's grandfather Abraham and bless Jacob's descendants. Needless to say, the gesture made a believer of Jacob.

L

Leviathan Satan declared Leviathan, a "piercing… crooked serpent," according to Isaiah 27:1, the ruler of all maritime regions. In the Book of Jonah in the Hebrew Bible, Leviathan is the whale who gulped Jonah whole and trapped him in its stomach for three days until God ordered Jonah's release.

Lilith According to Jewish lore, Lilith preceded Eve as Adam's wife. Their relationship failed due to Lilith's refusal to submit to Adam and her insistence that she was his equal. She eventually left him to join forces with the fallen angel Samael, and soon began unleashing her fury by strangling young children in their sleep. Lilith is sometimes identified as the serpent who tempted Eve in the Garden of Eden.

Lucifer Lucifer, which means "light-bearer" or "bearer of fire" is mentioned in the Bible only in Isaiah 14:12–15, a passage that details the once holy angel's desire to be as powerful as God. The term *satan* described an adversary in Old Testament times, but around 347–420, Lucifer became synonymous with Satan, a leader of fallen angels. This notion was upheld by John Milton's *Paradise Lost,* whose protagonist is called Lucifer.

M

Michael The only angel other than Gabriel named in the Bible, Michael ("who is as God") is the highest ranking of the angels. He lead God's army to defeat Satan and his fallen angels in the war in heaven. The image of his armored frame standing victorious over the dragon, Satan, has been depicted countless times in art.

mysterious stranger An angel who materializes in the form of a male or female human to tend to mortals in need. Like real humans, mysterious strangers eat; speak, although minimally; and are dressed according to standard. Because they disappear upon resolving a mortal's problem, it is often unclear whether these strangers were angels or actually human.

N

Nike The Greek winged goddess who represented triumph in sport, music, and battle, and influenced the notion of winged angels.

P

Pravuil The record-keeping archangel who assisted Enoch with writing down his experiences in heaven.

R

Raphael The archangel Raphael ("God's healing") is associated with the restoration of health, and is said to tend to the healing of Earth and its mortal inhabitants. In the apocryphal Book of Tobit, Raphael guides Tobias as he travels. Accordingly, Raphael, who is often depicted bearing a staff, is the guardian angel of travelers, especially pilgrims.

Remiel Meaning "Mercy of God," Remiel is the angel who leads souls to Judgment.

S

Sandalphon According to Jewish legend, Sandalphon is the angel identity the prophet Elijah adopted after being delivered into heaven in a chariot of flames.

Satan The supreme lord of hell and ruler of its demons.

Semyaza Semyaza (sometimes Shamayza) is the leader of angels who fell. As punishment for his sins, including living in sin with women, Semyaza hangs, head down, between heaven and Earth in the constellation Orion.

T

Tobit, apocryphal book of The Apochrypha includes the book of Tobit, a domestic tale named after a virtuous Jew of the same name who is in exile. Its contents include both angels and demons, and is considered the source of Raphael's popularity in angel lore.

U

Uriel Meaning "fire of God," Uriel is credited with warning Noah of the flood, guarding the entrance to Eden with a flaming sword, and as being the angel who wrestles with Jacob. John Milton refers to him as Regent of the Sun and "the sharpest-sighted" entity in heaven.

V

Verdelet Master of ceremonies in hell.

W

Wings Winged beings didn't become popular in art until the fourth century A.D. The flowing, feathery appendages were a mark of angels' ability to travel between heaven and Earth, carrying out divine purpose with inexplicable speed. However, not all angels had wings. There are several accounts in the Bible in which angels were human (and obviously wingless) in appearance.

Z

Zodiac angels Twelve angels preside over the twelve houses of the zodiac, according to occult folklore. However only Gabriel, the angel assigned to Aquarius, is associated with the angels of the Bible.

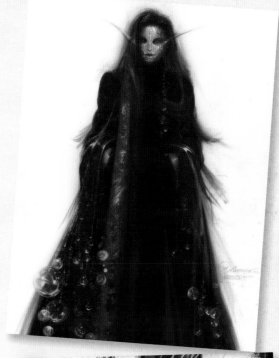

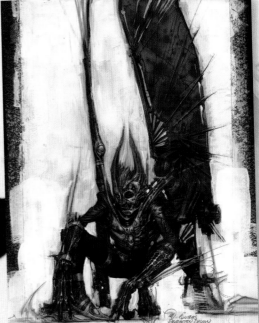

until the next life

Well done! You weathered your journey into the Fantasy Underground. In this installment, you discovered techniques to draw angels as depicted in classical art, as well as demonic angels in a variety of traditional guises—and even some modern interpretations of angels who've fallen from grace. You dabbled in black-and-white illustrations, tried your hand at paints, and experimented with computer manipulation to give your images that essential otherworldly effect. Elusive as they are, angels are no longer out of your realm. You've met them, you've drawn them, you know them (except when you don't realize it's them). If you've satisfactorily completed these projects, you're certainly entitled to your wings. Until your next journey into the Fantasy Underground, remember: Evil comes in all forms—and if you spot an angel on earth, it could be among the fallen.

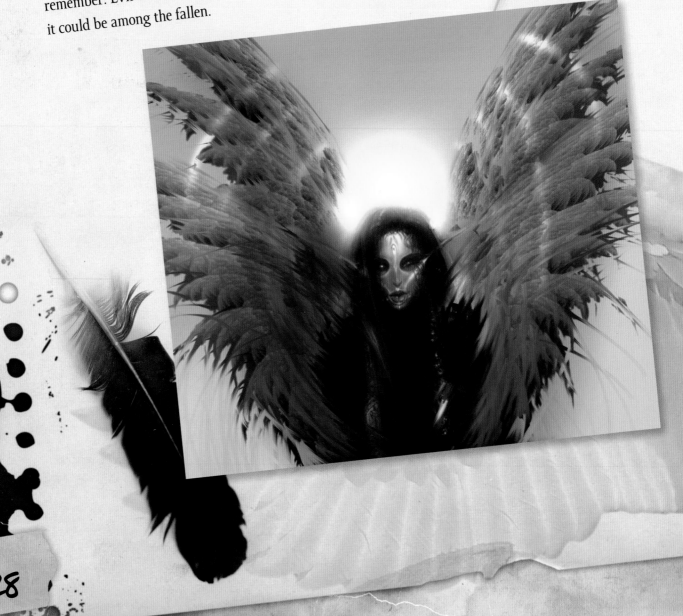